Dynamic Still Lifes in Watercolor

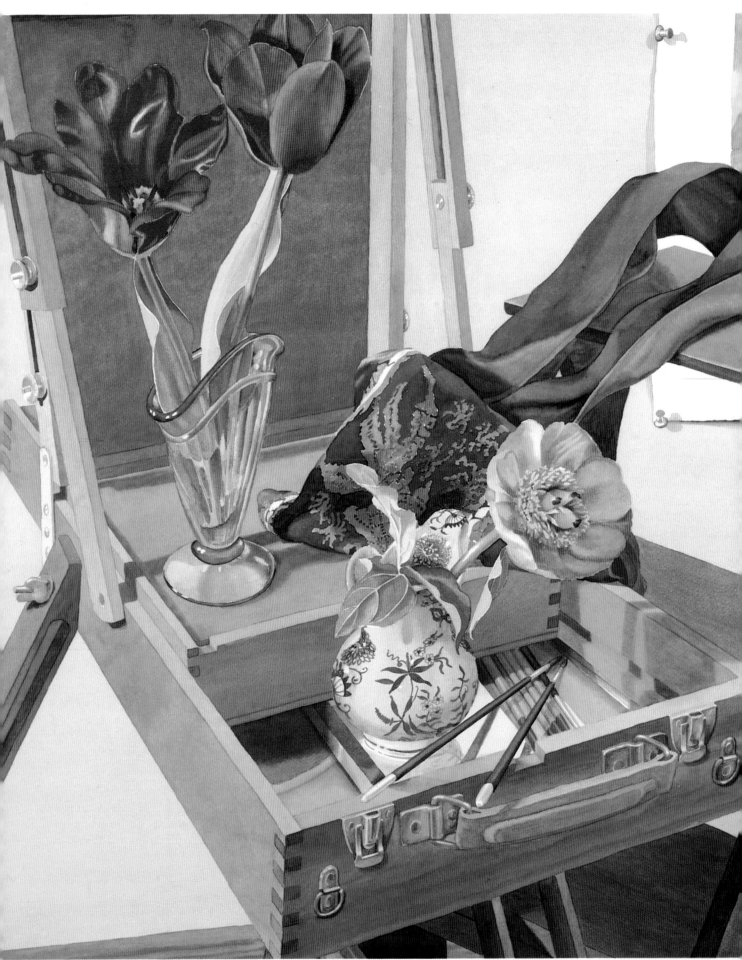

EASEL PAINTING, 31″ x 27″ (79 x 69 cm), 1982, courtesy Brooke Alexander, Inc., New York. Photo: Nancy Lloyd

Dynamic Still Lifes in Watercolor

BY M. STEPHEN DOHERTY

WATSON-GUPTILL PUBLICATIONS
NEW YORK

First published 1983 in New York by Watson-Guptill Publications,
a division of Billboard Publications, Inc.,
1515 Broadway, New York, N.Y. 10036

Library of Congress Cataloging in Publication Data

Doherty, M. Stephen.
　Dynamic still lifes in watercolor.
　Includes index.
　1. Freckelton, Sondra. 2. Still-life in art.
3. Water-color painting—Technique. I. Title.
ND1839.F74D6 1983　　　759.13　　　82-23889
ISBN 0-8230-1583-1

Distributed in the United Kingdom by Phaidon Press Ltd., Littlegate
House, St. Ebbe's St., Oxford

Manufactured in Japan

3　4　5　6　7　8　9/86　85

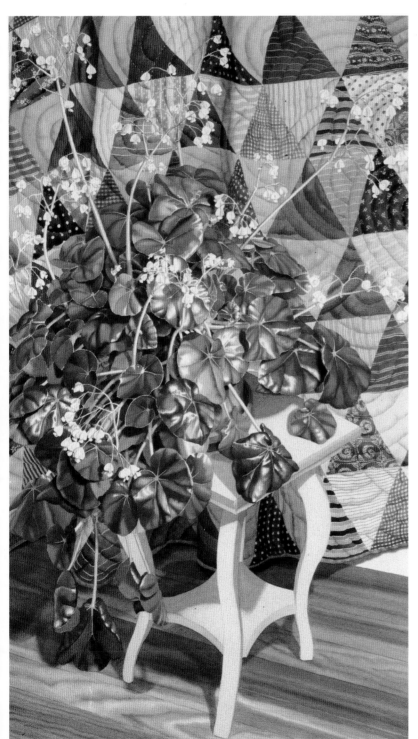

BEEFSTEAK BEGONIA AND ARKANSAS QUILT, 54" x 34" (137 x 86 cm), 1981,
private collection. Photo: Nancy Lloyd

✎ Acknowledgments

My contributions to this book were made possible through the help and support of the following people, whom I would like to thank: Anne Wilfer, Irene Ingalls, and Dean Hartung, for their enthusiastic participation in the workshops; Nancy Lloyd, for making herself available whenever needed to ensure pertinent photographs of quality throughout the book; Dana Van Horn, who provided me with more hours in the day by giving generously of his time and support; Jalane and Richard Davidson, for their invaluable suggestions and interest; and, of course, my husband, Jack Beal—whose support is always there, and who has always been my best critic—for his extra efforts as sounding board and "in-house" editor.

I also want to thank Betty Vera, our editor, for her most adroit and effective work in shaping and organizing the text and format; and Steve Doherty, for starting it all, for smoothing the way, and especially for his warm and generous nature, which made working with him a great pleasure.

—Sondra Freckelton

I return the same kind remarks to Sondra, and I want to thank her for sharing her art and her life with me and the readers of this book. I also echo her praises of editor Betty Vera, who sewed the project together when we delivered scattered pieces. David Lewis, Dorothy Spencer, and Robert Fillie of Watson-Guptill Publications also have contributed their extraordinary talents to the publication, and for that I thank them. Special thanks to Glenn Heffernan, Robin Longman, Stanley Marcus, and Fredy Kaplan of *American Artist* magazine, and to my generous friends Rick and Sue Murphy. Finally, my thanks to the three people who give me greatest support: Sara, Clare, and Michael Doherty.

—M. Stephen Doherty

CONTENTS

BLUE CHENILLE,
37" x 36" (94 x 91 cm), 1982,
courtesy Brooke Alexander, Inc.,
New York. Photo: Nancy Lloyd

BOUQUET AND TOMATO DISH, *36½″ x 31″ (93 x 79 cm), 1981, courtesy Brooke Alexander, Inc., New York. Photo: Nancy Lloyd*

PREFACE

❧ *The Sense and Sensibility of Sondra Freckelton's Watercolors*

My purpose in writing this book is to document the working methods and finished paintings of Sondra Freckelton, one of the most extraordinary artists I have had the pleasure of knowing. In so doing, I hope to bring attention to her work and at the same time inspire other artists to achieve the same level of skill and expression in their own paintings. Watercolors were once categorized, along with drawings and prints, as less valuable and permanent than works of art in other media. That attitude has changed in recent years, in large part because artists like Sondra Freckelton are dedicated to raising the level of skill and ambition being brought to the medium.

Freckelton's subject matter is usually a still life setup, and this book will be particularly helpful to those interested in similar kinds of subjects. It is Freckelton's belief—and mine—that artists should paint what they know best, what they observe and study. Still life painting lends itself well to personal expression because artists can select objects from their everyday environment that have significance for them. However, an artist need not be a still life painter to benefit enormously from what Freckelton has to teach, for her approach to painting in watercolor can be applied to almost any subject.

What follows in these pages is a carefully documented, illustrated account of Freckelton's working procedures which should help other artists to understand the intellectual, emotional, and technical development behind her paintings. Freckelton's method of working with the transparent medium of watercolor is one that takes advantage of the paper surface and the brilliant clarity of the pigment, while avoiding the problems that can result from the unalterable character of the paint. By stressing careful planning and practice, Freckelton achieves a deliberate, clear expression in her paintings. Her mastery of her medium leaves her free to observe the visual world and sensitively interpret her sensory and emotional responses to it. I hope that an understanding of Freckelton's way of working will make it possible for readers to discover their own meaningful approach to watercolor, as well as to experience the excitement of producing a thoughtful personal interpretation of a subject.

It is important to stress that skill without expression—"sense" without "sensibility"—is not art. As Freckelton says: "A painting which is just a solution of intellectual problems, or which is simply a record of visual fact, is not a painting to me. Only when these things are combined, chosen, and juggled by the artist do they become interesting for me to look at. A work combining sense *and* sensibility is a work of art. Anything less is a fragment."

Because this book is about an artist who has definite opinions to express, it is more than the usual collaboration between artist and author. I have quoted Sondra Freckelton directly and at length throughout; most of these remarks have been set in italic type to distinguish them from my interpretations as author.

—M. STEPHEN DOHERTY

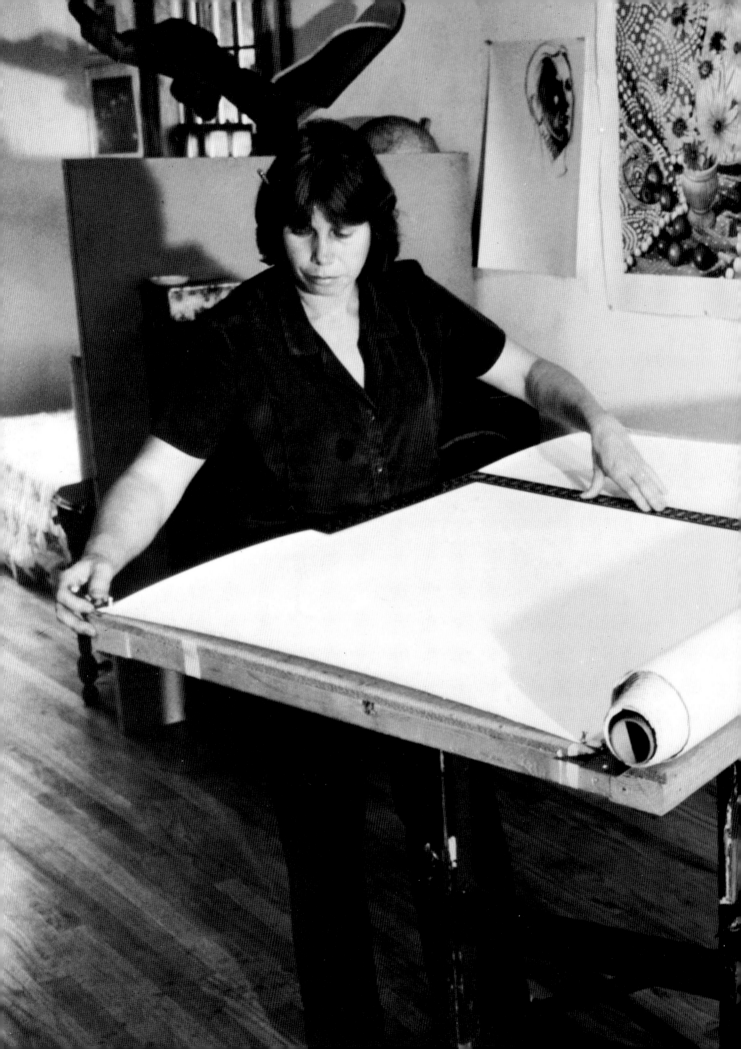

Part One

Introduction to the Artist

Because Sondra Freckelton's paintings come directly from her environment and life experiences, it is important to know something about her. Freckelton has worked hard to arrive at what seems to be an ideal life-style for an artist. She enjoys the benefits of working in both an urban and a rural environment, and her paintings are coveted by major collectors around the country. This enviable situation was achieved through the same kind of purposeful effort that goes into her artwork. It is the intention of this book to help other artists develop a responsiveness to their own unique experiences, using Freckelton's life and art as a model.

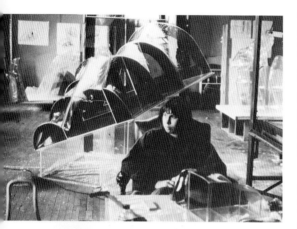

Transparency became an important aspect of Freckelton's sculptures during the 1960s, and the watercolor sketches she made for them prefigured her later watercolor paintings.

The plants, fruits, rocks, animals, quilts, and gardens Sondra Freckelton paints come directly from her environment in New York City and from her farm in upstate New York, where she lives for seven months of the year. Her paintings and her daily living are so interconnected that it is quite natural for her to use these personal objects in her work. In fact, this is as it should be for any artist. To paraphrase a statement Freckelton's husband, Jack Beal, is known for making: her art is her life, and her life is her art.

I use certain objects in my painting rather constantly. Most of the paintings that I have done contain some kind of handwork. The quilts, pillows, lace, and crocheted or embroidered cloth were all made by someone with care and a concern about the quality of life. They are the quiet work of housewives and artisans. These things are our visual history—the history we never read about in books. They don't speak about wars and kings, but about life— about how we slept and ate and dreamed and lived. They are about the things that we do now, have done before, and will be doing forever. So I think of them as important to my work in more ways than their more obvious aesthetic or formalistic usage might imply to the average viewer.

Freckelton developed this philosophic attitude in much the same way she developed her interest in and her skill in using watercolor: through self-instruction and self-criticism. She started with simple still life paintings of plants around her house and gradually improved on both the content and the techniques. She examined all aspects of her work and searched for ways of improving on what she had completed. That process continues today as Freckelton challenges herself to grow continually as an artist.

Although Freckelton has used watercolor from the time she was a student at the Art Institute of Chicago in the 1950s, it was not until the mid-1970s that she began to concentrate on the medium. Before then she was known as a sculptor who fashioned abstract shapes in wood and plastic, exhibiting them under her married name, Sondra Beal. In the 1950s and early 1960s her sculpture was composed of interlocking wooden forms that projected into space. Sometimes facets of these forms were painted, and sometimes the parts were constructed to move in space.

Freckelton became interested in vacuum-formed plastic in the 1960s, and she started making both free-standing and wall-hung

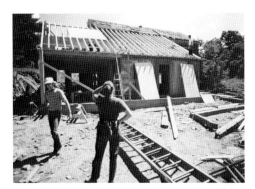

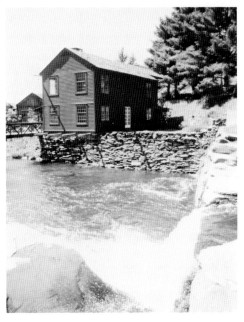

The renovation of a former mill (shown in progress, top) provided ideal living quarters and studio space for Freckelton and her husband; they found its rural setting above a stream particularly appealing.

sculptures by forming clear plastic over honeycombed structures. Because these multifaceted sculptures presented transparent layers of gray tones, Freckelton used transparent watercolor to sketch the designs for them. The sculptures then became three-dimensional transformations of the watercolors. The visible inner structure of these vacuum-formed pieces—particularly the later wall reliefs—resembled the veins of a leaf, prefiguring Freckelton's watercolor paintings of begonias.

A number of important contemporary artists made a transition from abstract or expressionistic painting to realistic work in the 1960s. Alfred Leslie, William Bailey, Jack Beal, and Sondra Freckelton became part of what was called a "New Realism" movement that brought new respect to paintings of realistically represented subject matter. None of these artists abandoned the formal principles at work in their abstract paintings, and it is possible to recognize the natural and logical development from Freckelton's late vacuum-formed sculptures to her early watercolor paintings.

The connection between Freckelton's earlier and present work can also be seen in her last major piece of "sculpture," her rural home/studio in upstate New York. In 1974 Freckelton and her husband bought what was then the shell of an old mill near the town of Oneonta; they especially liked it because of its idyllic setting. The old mill was perched above a stream and a cascading waterfall, and it was surrounded by hills that separated the place from the main road and nearby farms. Jack and Sondra could see that the beamed structure of the mill was solid and, with a little squaring up, could be used as the "armature" for a new dwelling.

Living in a small trailer on the property, Sondra and Jack, with his assistants Dana Van Horn and William Eckert and crew of local carpenters, stripped what was left of the old mill down to its rough beams and started to build a larger home according to Sondra's architectural plans and models. The additions to the original structure were made around the perimeter, with new bathrooms, laundry facilities, fireplaces, and other services confined to these new rooms. The result is that the original structure of the mill lives within the new edifice.

A large, high-ceilinged studio was built on the second floor of the new house, with space provided for both Jack and Sondra to

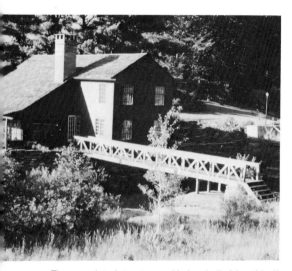

The completed structure, with the shell of the old mill still intact.

work, store their prints and paintings, and conduct business. The front third of the space, which can be entered from either the outside door or the staircase, contains their library of art books, a desk, and files of business papers. This area leads into a large work space lighted by spotlights attached to the beams overhead. At the back end of the room, near the windows that open out over the waterfall and stream, are more bookshelves, closed cases for paper and print storage, and two single beds for guests.

The slope of the hill outside the studio allowed for the design of a bridge connecting the second-floor studio with the road. The bridge makes it possible to haul large paintings directly from the studio to a van, and it also gives Sondra quick access to her gardens from the studio.

The months of working side by side with the carpenters and laborers resulted in a solid, handsomely detailed country home with a studio perfectly suited to Freckelton's needs. She can stand at her easel listening to the spray of the waterfall while the sunlight pours in through the windows facing the stream. Begonias soak up that light until they are ready to bloom, and then Freckelton moves them over to her work area and incorporates them into a still life arrangement.

Sketches, slices of old paintings, painted paper samples, and sheets of paint tests are pinned to the wall near Freckelton's work station. The lightweight furniture in the room can be moved easily to meet the artist's needs at the moment.

Freckelton uses this rural studio for seven months of the year, starting in early spring when the acres of gardens need preparation and ending when the heavy frosts have killed off her subject matter. During the growing and harvest seasons, Freckelton spends a portion of each day working in the flower and vegetable gardens. The rest of the day is given over to her painting. She spends an average of four weeks on each large watercolor, though some major pieces have taken more time to develop from the first sketches and opaque studies to the final painting. When a painting incorporates plant life available at different times of the growing season, she will work on the painting over a one- to three-month period as the different kinds of flowers and vegetables reach their peak.

Because of the intensity with which Freckelton works from liv-

15

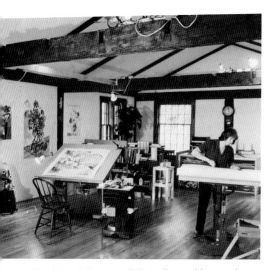

Freckelton's large, well-lit studio provides ample working space for her; the natural light from the windows is augmented by spotlights mounted on the beams above her work table.

ing, ever-changing subjects, she usually focuses on one major painting at a time. Other works may be in developmental stages, but she tries to avoid the tension of struggling with the growth and decay of subject matter in two or more paintings.

While Freckelton has done a great deal of sketching outdoors around her home, she confines her watercolor painting to the studio. The strong, always changing light, forceful winds, and annoying insects make outdoor painting too difficult for the kind of large-scale, controlled work she does. Outdoor photographs, oil studies, and watercolor sketches are fine for making quick, on-the-spot records; but to do the contemplative, carefully controlled painting of her major work, Freckelton must be free of the problems inherent in painting outdoors.

While the size and openness of the Oneonta studio allows Freckelton to place her easel or drawing table in any position, she generally prefers to have her work surface facing away from the natural sunlight coming in through the southern windows. She also positions her still life setup in such a way that it is illuminated almost entirely by artificial lights. These arrangements ensure uniformity in both the intensity and the color of the light while Freckelton is working on a painting. She gets the benefit of glowing sunlight as she moves about the room, but if that light should disappear, her subject matter will not be affected.

When Freckelton is at work, classical music can usually be heard playing softly in the studio. She is a lover of such music and compares the abstract compositions of musical presentations to those made in the visual arts.

Eventually Jack Beal and Dana Van Horn constructed their own studios away from the main farmhouse, and the second-floor space became Sondra's studio. While she sometimes shares it with the two men and with artists who come to visit, most of the time it is a space where she can spread her materials around and work without interruption.

Once winter moves in with all of its force, Freckelton and Beal relocate to a loft space in New York City. While the environment and working conditions there are not perfectly suited to Freckelton's painting, she finds the stimulation of the city beneficial.

In the city I cannot be as productive as I can in the country. I am a contemplative painter and need a quiet, undisturbed envi-

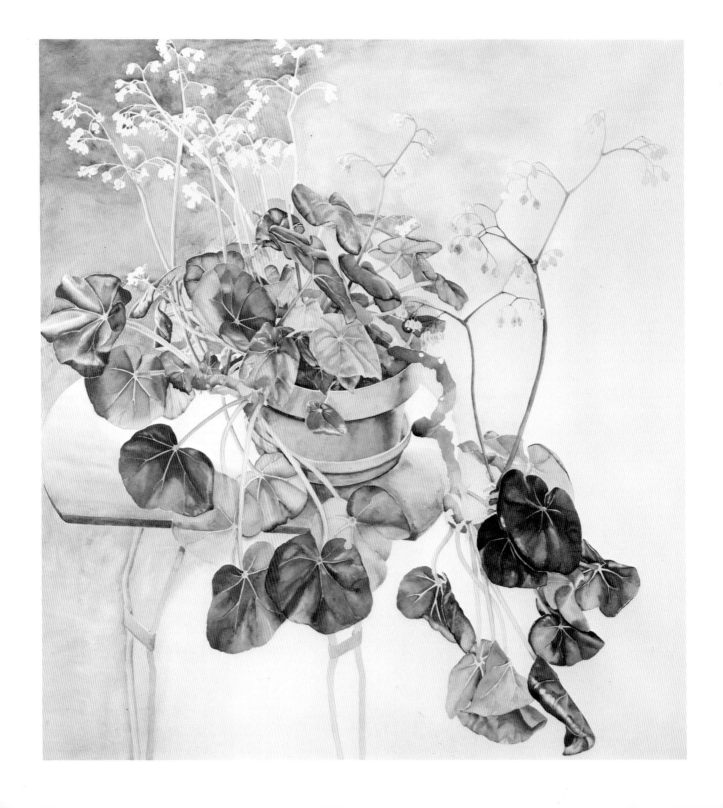

Beefsteak Begonia, 43⅛″ x 42½″ (110 x 108 cm), 1976, courtesy Brooke Alexander, Inc., New York. Begonias, a favorite painting subject for Freckelton, bloom in both her New York City loft and her sunny studio in the country.

ronment to do my best work. But while moving to the city studio does not provide me with the most ideal working conditions, it does provide me with another kind of resource. The energy of the city and the people in it—writers, poets, artists, musicians—provides a wellspring of riches. Art exhibitions, museums, operas, concerts, plays, intense conversations with friends and colleagues all add to the invigorating excitement of the city. I take in so much when I am there that I can't wait to get back to the country to let it all pour forth. My paintings are enriched by the intermeshing of these two different worlds. The city stimulates the conceptual part of my painting, the country energizes the responsive part, and between the two I can arrive at a full and involving challenge.

Freckelton and her husand have lived in a number of different lofts over the last twenty years, but whatever the address, these studio spaces have all been quite similar. They have offered a large open space where both artists could work; living quarters; storage areas; and proximity to other artists.

The paintings created in the city studio incorporate potted plants as opposed to fresh flowers, and they never take in the views outside the window, but otherwise they are not dramatically different from the paintings made in the upstate studio. Freckelton has dozens of potted plants around the loft, and she often forces spring bulbs to grow in dishes of water.

As an active professional artist, Freckelton's time is often given over to teaching workshops, judging competitions, and traveling to give lectures. She tries to schedule these activities during the winter and early spring so that her summers are available for painting on the farm. In recent years she has spent time working in New York with printers on editions of lithographs and pochoir prints. These are published by her dealer, Brooke Alexander.

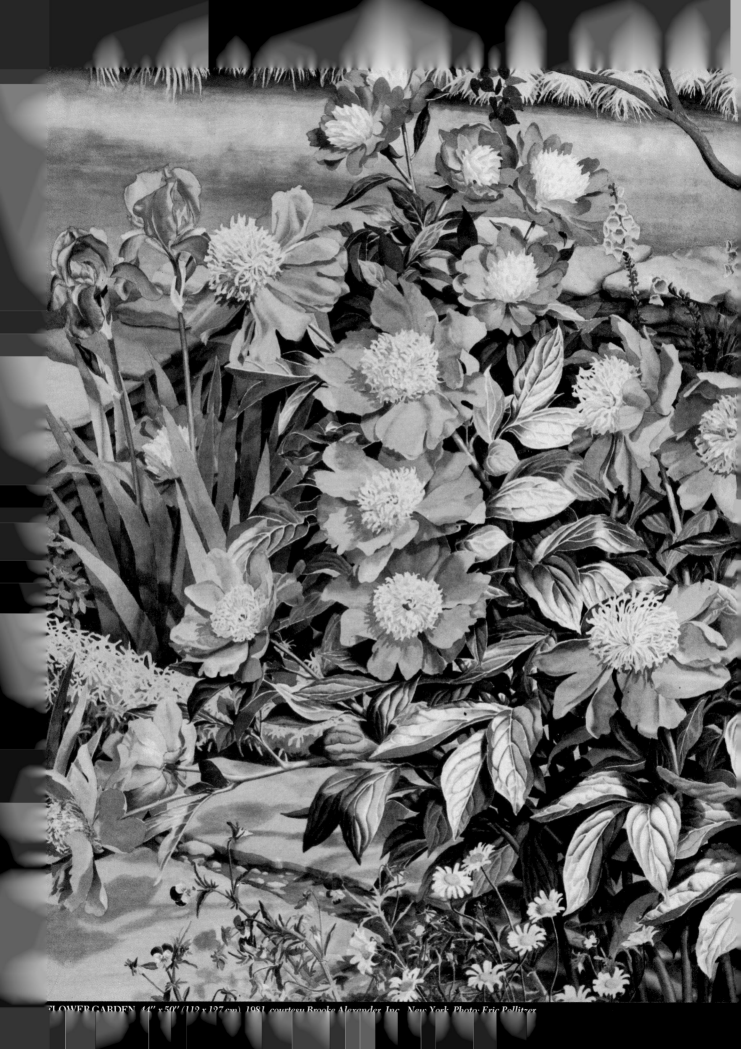

"FLOWER GARDEN," 44" x 50" (112 x 127 cm), 1981, courtesy Brooke Alexander, Inc., New York. Photo: Eric Pollitzer.

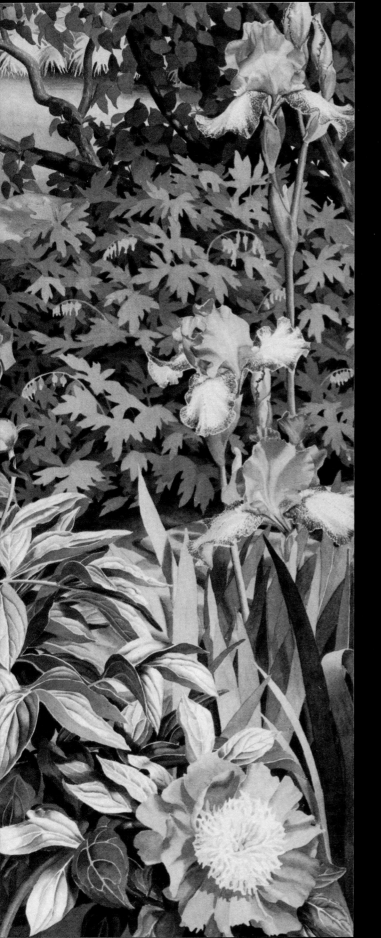

Sondra Freckelton's Working Procedures

Sondra Freckelton completed a painting in 1981 that presented her with almost every sort of challenge a watercolorist would face in painting a subject. It is a large, ambitious painting that was handled masterfully by the artist. Because it offers so much information about problems a watercolorist would want to be able to solve successfully, the evolution of this painting offers a good starting point for a discussion of the procedures Freckelton uses to begin, develop, and complete a painting. Because her method of handling the medium is based on sound principles, it is one that is worth study, even though she does employ personal methods adapted to her needs and the requirements of her paintings. The progress of the painting was documented in photographs by Nancy Lloyd.

SUBJECT MATTER

This selection of details from Freckelton's paintings includes her favorite subjects: plant life, fruits and vegetables, handmade textiles, and other everyday objects. (The complete paintings are shown on pages 105, 108, 109, and 112.)

Months before returning to the Oneonta farm in the spring, Freckelton had determined that she wanted to tackle an outdoor scene with natural forms existing in a deep landscape space. She was presenting herself with the classic problem of trying to record the changing scale, color, and lighting of objects as they recede into space and with the problem of devising a composition that would take the viewer back through that space in carefully paced visual steps. Added to these was the challenge of working with the changing conditions of an outdoor scene. After returning to the farm, she began thinking more specifically about her subject.

While most of Freckelton's paintings are of interior still life set-ups, she has done a number of outdoor scenes that relate to the painting illustrated here.

My gardens were getting very beautiful as June approached, and there was a peony bush in bud that I was especially fond of. I had been admiring it for years and knew that when it came into full bloom it would make a powerful focus for a garden painting. The irises nearby were already blooming and would be gone by the time the peony was at its best. It was obvious that I would have to paint the flowers where I wanted them in the painting when they were available. Their growth would dictate the sequential development of the painting. For instance, if I had to start painting an iris that my preparatory painting indicated as a background element, I would have to have a pretty good idea about the placement and color key of the whole painting before I began. I knew that the peony bush would only be in bloom for about two weeks, and I would have to know where the blossoms would be placed on my paper in order to paint them while I could refer to the living plant.

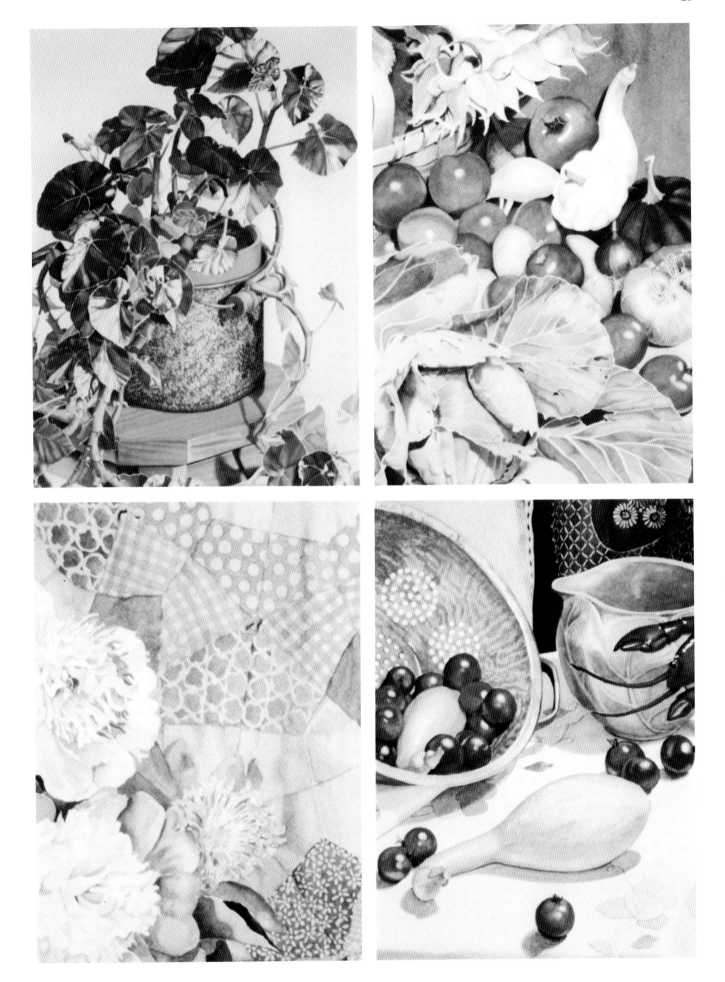

LIGHTING

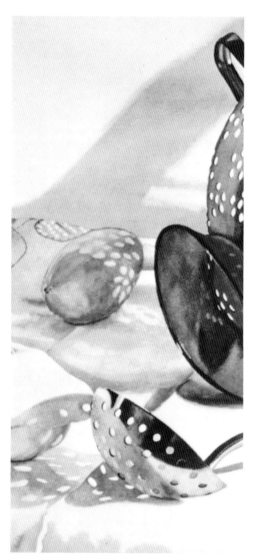

This detail from *Blue Colander* (see page 100) demonstrates the importance of light in Freckelton's paintings. Highlights, reflections, and cast shadows are painted as vividly as the objects themselves.

Because Freckelton likes to exaggerate the appearance of her subjects in order to give them a greater feeling of life, she usually lights her still life setups with strong spotlights. The strong highlights and well-defined shadows that result from this kind of presentation give her paintings drama. When Freckelton is working on an outdoor subject, as in this demonstration, she makes drawings and opaque studies on location to establish the basic lighting on her subject. When she brings live flowers into the studio to work from, she focuses artificial lights on them to mimic the natural lighting in the scene.

My working routine usually makes it impossible to use natural lighting. I work ten to twelve hours a day—from morning till well after the sun sets—and so often I have to block out the natural sunlight coming through my studio windows and light my subjects with a single, constant light source.

The direction and intensity of that light source is determined by the subject being painted. I might use back lighting on a plant that has a lovely translucent leaf or stem. This kind of lighting often helps me to see and convey more facets of the plant—its growth patterns, its structural makeup, its very existence. In some situations where I have chosen back lighting, I may have tried frontal lighting first but found that it only reflected light off the leaves and gave me a less interesting and less informative view of the delicate object.

Under other circumstances, I might want those qualities of simplified structure and enhanced two-dimensionality, and I would choose to use frontal lighting. In other situations, a strong, raking light from a low spotlight gives me distinct shadows that work into the composition of the painting. As yet another alternative, I may use a floodlamp with a soft light. My decision about lighting depends on the subject and the manner in which I want to present it.

Having described some of the situations in which I have used artificial light, I should also point out that on occasion I have set up a subject under sunlight and worked on a painting during certain times of the day. This approach obviously requires working over an extended period of time and having more than one painting in progress.

PREPARATORY STUDIES

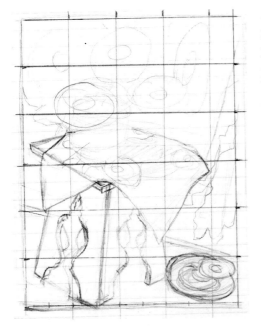

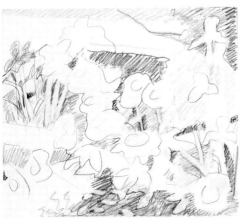

The rough sketch at top was done to establish the placement of the round shapes repeated throughout *Peonies and Bagel* (page 132). Freckelton did the compositional drawing above before starting her color study for the large outdoor painting demonstrated on these pages.

As Freckelton explains, the transitory nature of her subject made it necessary for her to develop preliminary sketches and oil studies before attempting the large watercolor. With these "blueprints" for the structure of the watercolor, she could approach the large painting without hesitation or fear of making marks that were not well placed.

Because painting in watercolor is a process of applying layers of permanent, transparent colors that stain the fibers of the paper, the medium does not allow for drastic changes in the composition of a painting. Adjustments can, of course, be made as a painting progresses, but these are really refinements, not redefinitions.

Compositional Drawings

In Freckelton's paintings one finds an ideal balance of richly patterned quilts, delicate flowers, broad leaves, angular tables, and soft shadows. Each of these visual elements serves a different compositional function, and the artist brings them together in a well-orchestrated composition. It is the preparatory drawings she makes that allow Freckelton to arrive at these balanced compositions. The importance of drawing has become something of a crusade for her.

The most common problem for artists who approach the watercolor medium is that they try to paint before they know how to draw. Drawing is simply and plainly a skill that must be learned and used. For a while artists accepted the myth that if you learned the skills of drawing and painting you would kill your natural instincts and your talent. Well, there couldn't be anything further from the truth. Far more people have been ruined by art teachers who say, "Whatever you have is precious and is going to come out," than by the teachers who emphasize sound, fundamental skills.

Drawing is especially critical in watercolor because once you have made a mark, you have to make another one to match it, or to counter it. That initial mark is important, and you can't take it away or change your mind in the middle.

You wouldn't start building a house without a blueprint—a drawing—and you shouldn't go about making a watercolor without having the same kind of clearly established plan worked out in advance. Watercolor doesn't give you more freedom than other

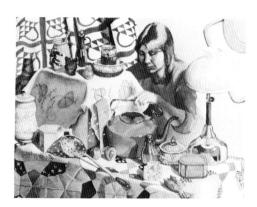

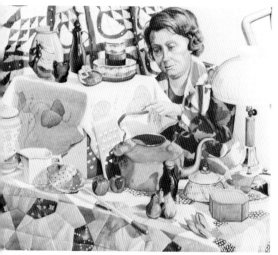

media—it gives you less because the marks you make on paper are, for all intents and purposes, permanent. That characteristic doesn't preclude creativity. On the contrary, if you are working from a clearly defined overall plan you will have the freedom to make creative changes and improvements instead of fighting a false start and ending with a confused statement.

When I work up a drawing, I am aiming to imply more on that paper than is actually in front of me. I want things to be more round, more spatial, more full of life than what I am actually looking at. I want things to be more alive than they really are. They have to look like they are going to burst, or fall, or do something. They can't just lie there. When I look at a setup and I look back to my painting, I want to find more life, more excitement, more energy on the sheet of paper than there is on the table full of objects.

When Freckelton refers to the drawing stage of her work, she is not just describing one preliminary phase in the process. Drawing is a constant and continuous procedure, and she is likely to make several different studies of the whole composition and of individual details that need clear definition before the painting is begun. These are not meant to be finished, refined drawings to be framed and hung on a wall. Rather, they are shorthand notations that she uses to visualize a compositional idea. Freckelton seldom saves these drawings after the painting is completed.

By making drawings, Freckelton can begin to see whether or not she has a composition that will lead the viewer's eye around the painting to various points of interest. The control of that movement is, to her, like the orchestration of musical instruments. There is a wide range of visual "sounds" one can introduce in a painting, and it is up to the artist to select and organize the "instruments" that will produce the "sounds" he or she wants in the composition. Some visual shapes, textures, and colors will relax the viewer and direct the eye around the painting slowly. Other compositional elements will move the viewer's attention quickly. The best compositions combine both complicated, arresting patterns and simple, flowing shapes.

❧ Preliminary Color Studies

Although Sondra Freckelton makes preparatory drawings to help establish her composition, they do not allow her to resolve ques-

The watercolor study at top enabled Freckelton to decide how she wanted to handle the open catalog page before putting it in the actual painting, above. The finished painting, *The Garden Plan*, is shown on pages 120–21.

tions related to color. For this reason, Freckelton places great emphasis on doing preliminary studies in oil paint or pastel. Studies can be made quickly on canvas, paper, or rag board that is inexpensive and portable. While there are times when these studies develop to the point of becoming completed paintings, generally Freckelton leaves them as loosely painted sketches that lack the refinement of her watercolors.

Although making oil studies for watercolors is an unusual approach, I did not invent the idea. This effective procedure has an impressive historical precedent: the great nineteenth-century painter Thomas Eakins, a firm believer in preparatory work, did detailed oil studies for many of his watercolors.

Freckelton deliberately uses opaque colors for these studies because, unlike watercolor, they can be completely reworked as the composition develops. Colors can be lightened, objects moved, values redefined, and entire sections repainted. She is free to resolve her composition without any concern for the finality of individual brush strokes.

Oil sketches can also be made on toned canvas, thus making it possible to work outdoors in bright sunlight without being blinded by the glare caused by working on pure white paper. This difference has been an important advantage to Freckelton during the summer months, when she often starts her paintings outdoors in the garden and around the stream on her farm.

Freckelton also uses watercolor paints for preparatory work, particularly when she is trying to resolve specific passages within a composition. She frequently makes small watercolor studies of unusual objects she has not painted before so that she can be certain of the best way to render an object in the context of the full-size painting. When she wanted to put an open book in a painting, she was uncertain about how she should depict the printed words. She made a watercolor study of the book and resolved the problem before incorporating it into her composition.

For the large outdoor watercolor demonstrated in this working sequence, Freckelton did several preparatory drawings (not shown) and then decided to do an oil study before beginning the actual watercolor painting.

By early June the flower garden in front of the house was filled with deep green foliage and a full spectrum of colorful flowers:

26

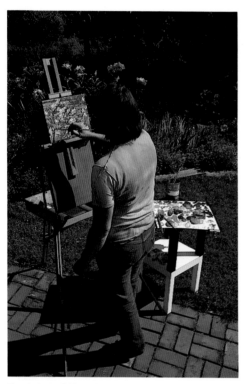

Freckelton did her oil study on the spot, manipulating the opaque pigments freely to achieve an accurate record of the colors, values, and placement of the plants in her garden. The peony bush (opposite page, top) was to be the focal point of the painting, as shown in the completed oil sketch, below. This study would serve as a guide for the color key and composition of the actual watercolor painting.

bleeding heart, violas, pansies, white daisies, foxglove, iris, and Japanese peonies. Although some of the irises were still in bud and the peonies were just beginning to bloom, she could begin her oil study now. She chose a location that would allow her a good view of the peony bush, which would be the center of interest in the composition, and she set up her French easel and a small canvas that had been toned and sized with yellow ochre latex exterior house paint. Next to the easel she set up a makeshift taboret and laid out her colors on a pad of disposable waxed palette paper. She chose a variety of Winsor & Newton and Shiva oil colors ranging from the bright cadmium reds and yellows to the earth pigments: cadmium red, cadmium red deep, Shiva maximum red, cadmium yellow pale, cadmium lemon, cadmium yellow deep, permanent green deep, Shiva maximum VIII green, Shiva maximum V violet, ivory black, ultramarine blue, cerulean blue, cobalt blue, burnt umber, burnt sienna, yellow ochre, and permanent white. Also at hand were a container of gum turpentine (but no medium) and an assortment of flat and round bristle brushes from sizes 0 to 3.

Because the peony flowers were to be the dominant focus of the painting, I used them to set the color key of the painting—all other colors would relate to them in a more or less subordinate manner. Especially important in this painting, as in most outdoor or landscape paintings, would be the decisions I made about separating and unifying the many greens that ranged from almost yellow to very blue, and from bright to grayed tones. In the color sketch I indicated that most of the brightest and warmest color, as well as the greatest contrast from light to dark, would be in the foreground plants. The middleground would be well focused but painted in cooler and more muted colors and with less contrast. The part of the garden farther in the background would be painted with less articulated detail and would be even more subdued.

I also tried to capture other important information in the oil sketch: the appearance of the sunny outdoor light, the major directions and rhythms of the composition, how the deep recession of outdoor space would be handled, and how the painting would "read" overall.

☙ Photographic Aids

Like many contemporary painters, Freckelton uses photographs as an aid to her painting procedures. She takes instant photo-

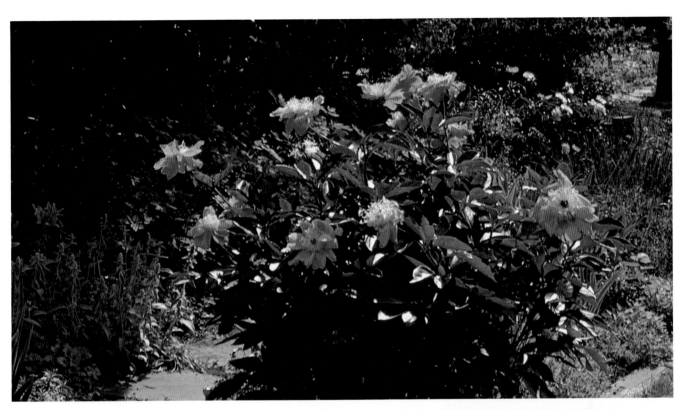

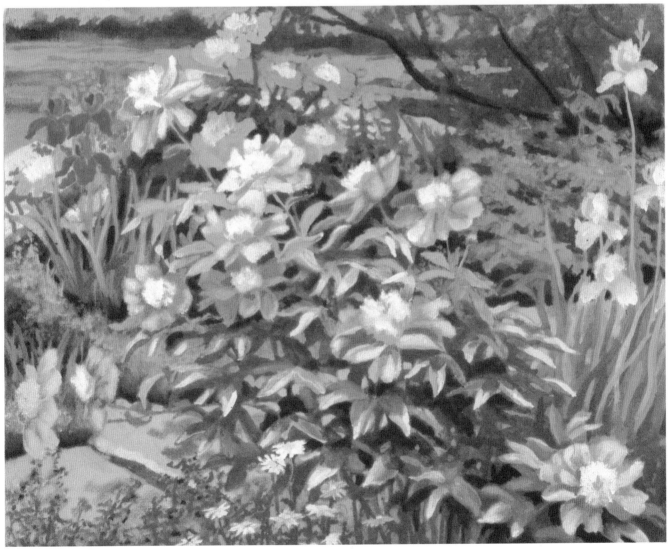

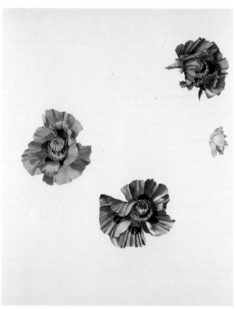

Top, a photograph has been marked with a grid to serve as a "map" for a painting; above, the key elements have been painted in place, using the photograph as a guide; and the finished painting, opposite, shows how Freckelton related the other elements of the composition to the dominant poppies. The painting was done for reproduction as a poster for the New York Botanical Garden.

graphs of her subject matter when she is using fresh flowers or other organic material that will change within a matter of hours, or when the objects are lit by sunlight. For instance, if Freckelton is painting flowers that will wilt during the month-long period when she is working on a watercolor, she takes color snapshots of the arrangement. Likewise, if the objects are set up outdoors where the shadows will shift dramatically during the day, a photograph gives her a record of how the objects were lighted.

Freckelton often draws a grid pattern across a snapshot that records the general composition of the painting she wants to create. A proportionate grid is then drawn on the watercolor paper so that some elements in the photograph can be enlarged and indicated in the correct place on the paper. This light sketch gives the artist a starting point, or a reference for the placement of objects on the paper. From this reference she makes decisions about alterations in scale and the relationships between objects.

I sometimes use 3" x 3" instant photographs as "maps" for the very large and complex watercolors. They are especially useful when there are objects in the painting that are so transitory they will not last for the duration of the painting process. I can locate these elements in the composition from the "map" and proceed to draw them from life and paint them on the page.

For example, if I am painting a flower, I can use my "map" as a guide to locate the flower in the composition and paint it from life while it is in its best condition, knowing that it will be properly placed relative to the other objects and elements when the painting is further along. Then, with the same procedure, I can move on to the next unstable elements, and so on, until I am finally left with the parts of the painting that will remain stationary. At that point I can work more slowly all over the page and begin to integrate the composition fully. I have settled upon this technique as one of the few ways of making the kind of paintings I envision—especially when my still life subjects won't stay still.

I never paint from the photographs because I insist on having the real thing in front of me. There is so much more information revealed by the actual subject, and that's what makes painting exciting. The joy of baring my eyes and really looking at something. The subtle discoveries seem like major revelations—and sometimes they are. Looking hard is my favorite part of painting.

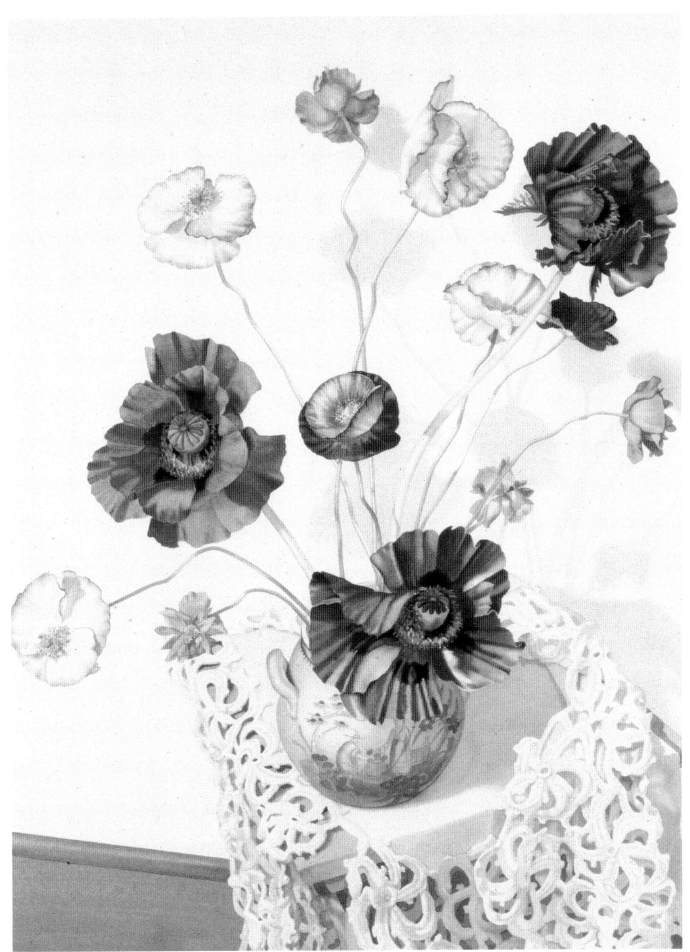

Poppies and Lace, 38″ x 30″ (97 x 76 cm), 1981, private collection. Photo: Nancy Lloyd

PREPARING TO PAINT

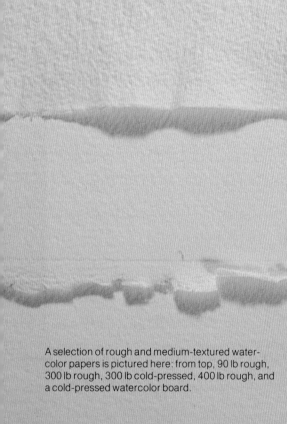

A selection of rough and medium-textured watercolor papers is pictured here: from top, 90 lb rough, 300 lb rough, 300 lb cold-pressed, 400 lb rough, and a cold-pressed watercolor board.

Once Freckelton was ready to begin the actual watercolor, she began to select and prepare her painting supplies and set up her work area in the studio.

✒ Selecting the Right Paper

There are dozens of watercolor papers on the market today, each with its own unique characteristics. Papers can vary in weight, dimensions, texture, fiber content, and the amount of sizing used. No one paper is right or wrong as a painting surface. What matters most is how appropriate the paper is for the kind of painting an artist wants to create.

Freckelton most often uses Arches 140 lb cold-pressed paper. This slightly textured, well-sized paper is available in both sheets and rolls, and Freckelton buys it in 44-inch-wide rolls so that she can make large, single-sheet watercolors when a large scale seems desirable.

I like this paper because it is so versatile. I can layer successive wet applications of color on it or apply the paint with a dry brush, and the paper maintains its shape and medium tooth. I can also sponge or lift colors off. The paper takes a good-looking wash with most colors, though with some it has a tendency to "holiday," or leave flecks of white in the washed areas. If the flecks are undesirable, they can be covered with another light wash. The paper also takes wet-in-wet applications of color with no "sinking," and I can get a good, crisp line or edge when needed. This paper can take a lot of surface manipulation and still look fresh.

Even though Freckelton uses the 140 lb Arches most often, she is always trying new papers that might prove to be useful.

An artist has to keep experimenting with materials. It's like vocabulary lessons in school—you learn as many new words as you can, not because the old words are worn out but because the more words you know, the more accurate you can be in your descriptions. Papers, brushes, and colors are the artist's vocabulary, and they should be used as effectively as possible.

For the large-scale outdoor watercolor demonstrated here, the medium-weight (140 lb) Arches watercolor paper was ideal, and Freckelton cut a 50″ (127 cm) length from the 44″ (112 cm)-wide roll.

❧ *Preparing the Work Surface*

Next Freckelton needed to mount the watercolor paper on her work surface. When working in watercolor, an artist must be able to adjust the position of the work surface easily and quickly. This can become difficult when the watercolorist is working on a large sheet of paper attached to a heavy board, for the weight of the board makes it hard to maneuver it as easily as a small block of watercolor paper.

For her large outdoor painting, Freckelton cut an appropriate length from a roll of her favorite 140 lb paper.

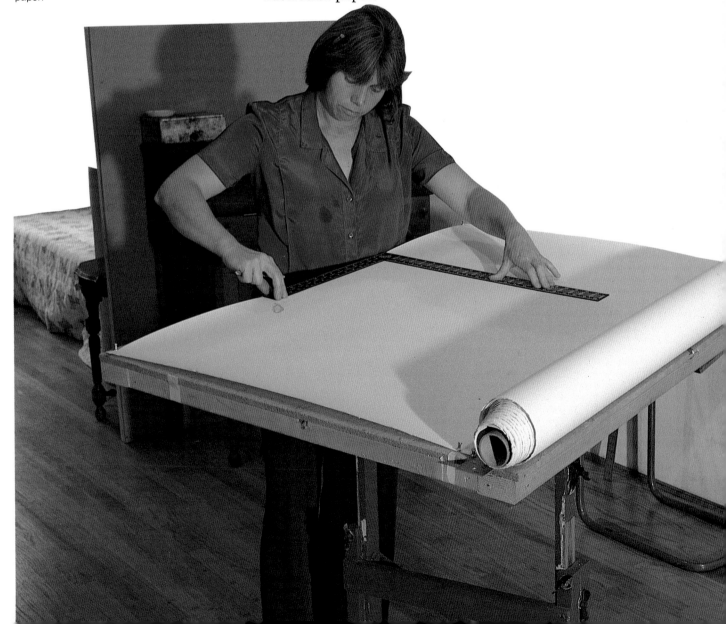

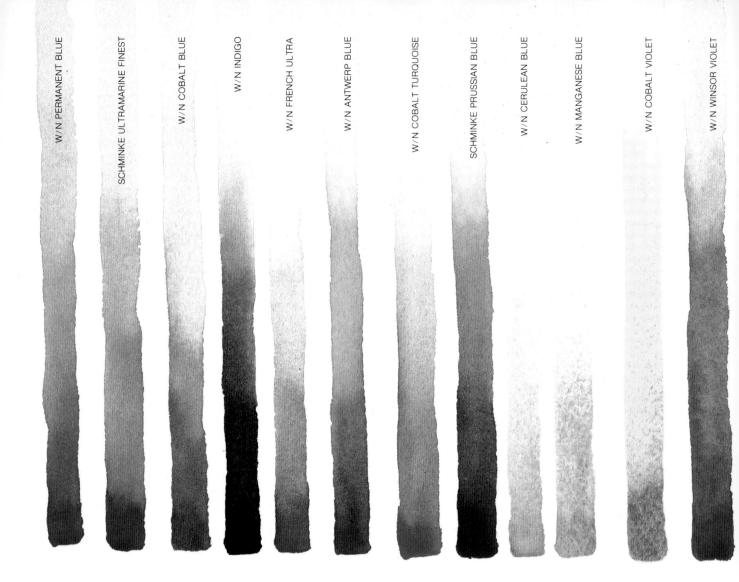

W/N PERMANENT BLUE
SCHMINKE ULTRAMARINE FINEST
W/N COBALT BLUE
W/N INDIGO
W/N FRENCH ULTRA
W/N ANTWERP BLUE
W/N COBALT TURQUOISE
SCHMINKE PRUSSIAN BLUE
W/N CERULEAN BLUE
W/N MANGANESE BLUE
W/N COBALT VIOLET
W/N WINSOR VIOLET

Freckelton's well-organized color charts enable her to see at a glance how any color in her palette will look on the paper she has selected, from a dense saturation of color to the most delicate wash.

Freckelton uses a combination easel and drafting table and finds that this is a perfect solution to the problem of handling large sheets of watercolor paper on a board. She clamps a piece of ½″ (about 1 cm) Homasote or fiber board, which has been nailed to a framework, to the drafting table, which swivels easily. This makes it possible for her to tilt the board from side to side or from a horizontal position to one that is vertical. The table can also be elevated or lowered, bringing any section of the painting to a convenient working height.

The table allows me to view the painting from a distance just as if it were propped up on an easel. Once I have made a decision about what to do next, I can tilt the painting and resume work while the information from the viewing is still fresh in my mind.

❧ Colors

Sondra Freckelton works with a large and varied palette of colors—and they are all available on her porcelain mixing dishes at all times when she is painting. Because she works on a large scale, she buys her watercolors in tubes.

The invention of tube colors has been one of the major contributions to making large watercolors, and to making watercolor paintings a little differently than they used to be made. Previously, art-

W/N SAP GREEN

SCHMINKE SUNPROOF OLIVE

ROWNEY HOOKER'S GREEN DARK

W/N HOOKER'S GREEN DARK

W/N HOOKER'S GREEN LIGHT

W/N TERRE VERTE

W/N OXIDE OF CHROMIUM

W/N OLIVE GREEN

SCHMINKE CINNABAR GREEN DEEP

SCHMINKE PRUSSIAN GREEN

W/N PRUSSIAN GREEN

SCHMINKE MONASTRAL GREEN

W/N COBALT GREEN

ists had to take rubbing cakes and mix the colors up as they went along. As a result, watercolor paintings were done on a much smaller scale, or these paints were employed as tints on large cartoons or sketches. Tube colors changed the way of painting and the scale of the paintings.

With premixed tube colors, however, there also came a wider variance in the colors manufactured for artists. There are now dozens of paint manufacturers who produce watercolor according to their own formulas and with their own selection of pigments and binding agents. The result is that different brands of paint that are labeled the same color may in fact be totally different in both quality and appearance. To see this difference, one only needs to buy three tubes of a cadmium red, each manufactured by a different company. When they are painted out in test swatches, the differences between them—in both the hue and the paint quality—will be apparent. One cadmium red will look orange in comparison to the others, while a second will probably appear crimson. Obviously, each brand would have a different effect when used in creating a painting.

Freckelton probably has more tubes of paint than most watercolorists, and she goes to great lengths to add to her supply. She is particularly fond of Schminke paints, a German brand as yet

Listed here are 64 colors that are squeezed out onto the labeled compartments of Sondra Freckelton's porcelain mixing dishes (inset) when she is painting. Colors are replenished as necessary from the supply stored in the drawers beneath her taboret.

REDS

Rowney
PERMANENT MAGENTA

Schminke
MADDER LACQUE DEEP
CARMINE RED
CADMIUM RED LIGHT
PERMANENT RED 3

Winsor & Newton
ROSE DORE
ALIZARIN CARMINE
BRIGHT RED
PERMANENT ROSE
WINSOR RED
CADMIUM RED
CADMIUM RED DEEP
CADMIUM SCARLET
PERMANENT MAGENTA
ALIZARIN CRIMSON

YELLOWS

Old Holland
CADMIUM YELLOW DEEP
SCHEVENINGEN DEEP

Schminke
YELLOW OCHRE #1
SUNPROOF YELLOW LIGHT
SUNPROOF YELLOW DEEP
BRILLIANT YELLOW #1
CADMIUM YELLOW LIGHT

Winsor & Newton
CHROME YELLOW
CADMIUM YELLOW
LEMON YELLOW
CADMIUM ORANGE

GREENS

Rowney
HOOKER'S GREEN #2

Schminke
SUNPROOF OLIVE
CINNABAR GREEN DEEP
MONASTRAL GREEN

Winsor & Newton
SAP GREEN
HOOKER'S GREEN DARK
HOOKER'S GREEN LIGHT
OXIDE OF CHROMIUM
WINSOR EMERALD

BLUES

Schminke
ULTRAMARINE FINEST
PRUSSIAN BLUE

Winsor & Newton
PERMANENT BLUE
COBALT BLUE
ANTWERP BLUE
COBALT TURQUOISE
CERULEAN BLUE

VIOLETS

Winsor & Newton
COBALT VIOLET
WINSOR VIOLET

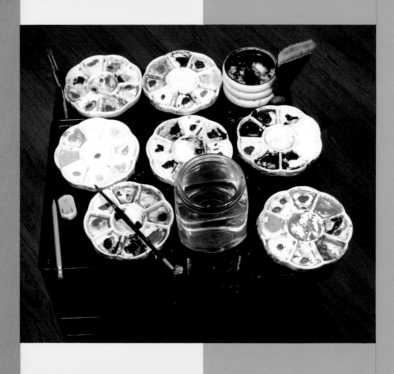

BROWNS

Grumbacher
SEPIA

Schminke
RAW UMBER
BURNT UMBER
ENGLISH RED LIGHT
BURNT GREEN EARTH
BURNT YELLOW OCHRE
SEPIA BROWN COLOUR

Winsor & Newton
BURNT SIENNA
LIGHT RED
BURNT UMBER
WARM SEPIA
SEPIA

BLACKS & GRAYS

Schminke
NEUTRAL TINT
LAMP BLACK

Winsor & Newton
IVORY BLACK
LAMP BLACK
CHARCOAL GREY
DAVY'S GREY
NEUTRAL TINT
PAYNE'S GREY

unavailable in the United States. Anytime she hears that someone is traveling to Germany, she asks them to purchase tubes of this paint for her.

The only way a watercolorist can be certain that the color in the tube is the one that is wanted is to try it out on a piece of watercolor paper. Freckelton has made several charts for herself with tests of every paint she might use. The tests are organized by color, and those that have the same or similar names are laid next to each other for comparison. Each color is put down directly from the tube and graduated to a thin wash on the test chart in ½″ (1 cm)-wide strips that extend to 4 or 5 inches (10-12 cm) in length. Each of the colors is marked with the initials of the manufacturer and the manufacturer's name for that particular color—such as "W-N Winsor Blue" for the color manufactured by Winsor & Newton, or "R. Ultramarine" for Rowney ultramarine blue. These tests show both the color and the degree to which the pigments are suspended in the paint. Some colors are grainy because of their pigments or because of the way they were manufactured. For example, if the pigments are not finely ground and mixed properly, the paint will appear grainy when applied to paper.

Palette and Taboret

For her palette, Freckelton uses the round porcelain watercolor dishes that are divided up like sections of grapefruit. She has eight of these stacked up on her taboret, each one reserved for a specific family of colors. The name of each color has been written with indelible ink on the outside of the section of the dish so that the artist can refer to her color chart and know exactly how that paint will look on the watercolor paper. Separate nesting dishes are used for mixing colors or for preparing washes that will be used to cover large areas.

Before beginning her large watercolor of the peonies and irises, Freckelton set out all eight sectioned dishes on her taboret and squeezed the appropriate color into each section so that she would have every hue in every color family available when she began to paint. Nearby were a container of clear water, a pencil and eraser, and her brushes. In the drawer of the taboret were extra tubes of paint and brushes, sponges, and sundries.

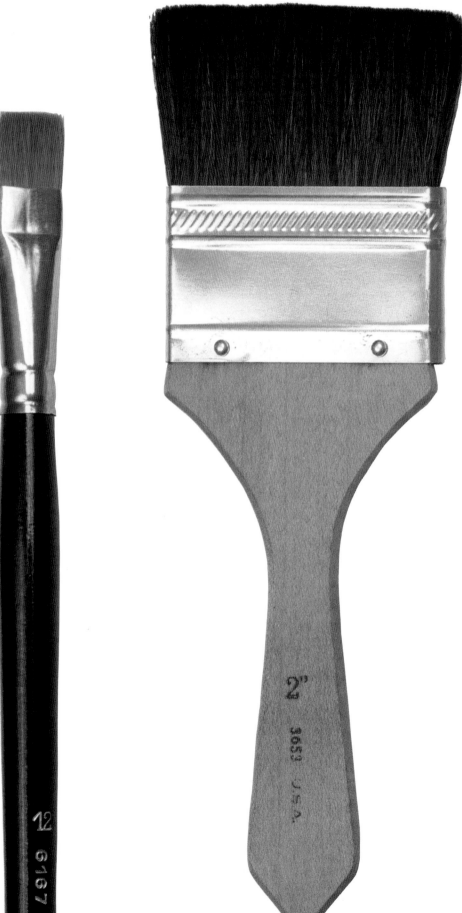

Pictured, from left, are just a few of the many types of watercolor brushes available to artists: a no. 12 kolinsky sable brush, a 2″ (5 cm) camel hair wash brush, a ¾″ (2 cm) poly-sable wash brush, and two no. 7 kolinsky sable brushes, one with a very fine point.

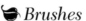

Brushes

Freckelton insists on using the finest watercolor brushes for her paintings because she feels that the responsiveness of the brush is critical to the success of her efforts.

A good kolinsky sable brush will hold a large reservoir of paint, and it will retain its shape and firm point so that I can release the smallest, most finely controlled line with light pressure and then push it more firmly, and finally lift it from the paper. The brush will immediately regain its original shape. An inferior brush, on the other hand, will lose its point and discharge its paint all at once with firm pressure, and it will not return to its original shape until dipped into water again. Poor brushes are certainly the prime reason for beginners' frustration with the "uncontrollability" of the medium.

Good brushes are expensive, but an artist can paint constantly for as long as a year with only two or three good brushes. Freckelton depends on three brushes for most of her painting: two no. 6 pointed kolinsky sables and one large Siberian-hair round for large washes. She uses the matched pair of no. 6 brushes because one of them is often so saturated with color—especially when she is using reds—that it is difficult to use that brush for removing paint in a controlled area or for laying on another clean color or graduating a delicate tone. The manner in which she works makes it necessary to always have a clean brush at hand. The only alternative would be for her to stop and wash out the color-saturated brush with mild soap and water.

If a brush is used many hours a day, every day, it will eventually lose its fine point and you will have to buy a new one. But while the old brush may not come to a sharp point, it can still be valuable for manipulating paint. I buy new brushes once a year, but I am still using good brushes that are twenty-two years old. It's important that the brushes be properly cared for, of course, which means that they are kept clean and stored flat with the hairs drawn to a point. My brushes are in almost constant use, and when I am painting I stand them upright, points upward, in holes in the top of my taboret. I store other brushes in drawers with plastic covers over the hairs, or I band them to a flat holder.

THE PAINTING PROCESS

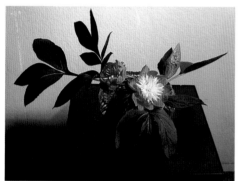

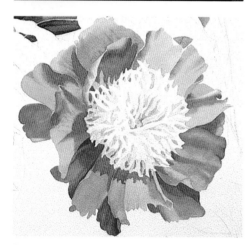

Top, Freckelton's oil sketch with a grid placed over it to serve as a "map" for her painting; middle, Freckelton's live "model" for the first peony blossom she painted, above. Opposite, Freckelton's line drawing for the peony; for purposes of reproduction here, the pencil lines are shown much darker than she actually drew them on her watercolor paper.

When Freckelton had assembled and prepared all her painting materials, she propped the completed oil sketch on the French easel and positioned it near her work surface. Near her work area she also assembled small tables, vases of flowers and leaves from the garden, and photographs of the plants in the garden. These would serve as references as she worked on specific areas of the painting. On the wall nearby were the charts showing how each of the tube colors extended with water would appear on this particular paper. Now she was ready to begin the painting.

🐦 Mapping Out the Painting

Referring to her oil study, Freckelton began by sketching in the various elements of the painting. She lightly outlined the shapes of the flowers, leaves, stems, stones, etc., in pencil to give an indication of their scale and placement. She did not render these elements in much detail at this stage. Later, she would draw each of the specific objects in the composition directly from life just before painting it.

I don't usually map out the whole painting at once, after I have done the preparatory study. I will always have the study to refer to, and meanwhile my subjects are blooming and dying. Since I know, from the references I have (the live subject itself and my studies of the subject) where specific important objects are going to be located, I can immediately begin with a flower that will be gone in a day or two.

Finally, when Freckelton was satisfied with the composition she had mapped out, she "cleaned up" the drawing. She erased any unnecessary lines, lightened or removed any lines not meant to show in the completed painting, and left just the barest pencil drawing to guide her paintbrush.

🐦 Establishing the Key Elements

Because the peonies were to be the focus of the painting, Freckelton began painting the petals of one of the foreground flowers, using a flower plucked from the bush as a model. That "model" was lighted and positioned to correspond with its attitude on the plant within the painting. For most of the flower petals, she laid down a basic pink tone with a fairly wet brush and allowed it to dry. Many of the petals had slightly different base colors, and so Frec-

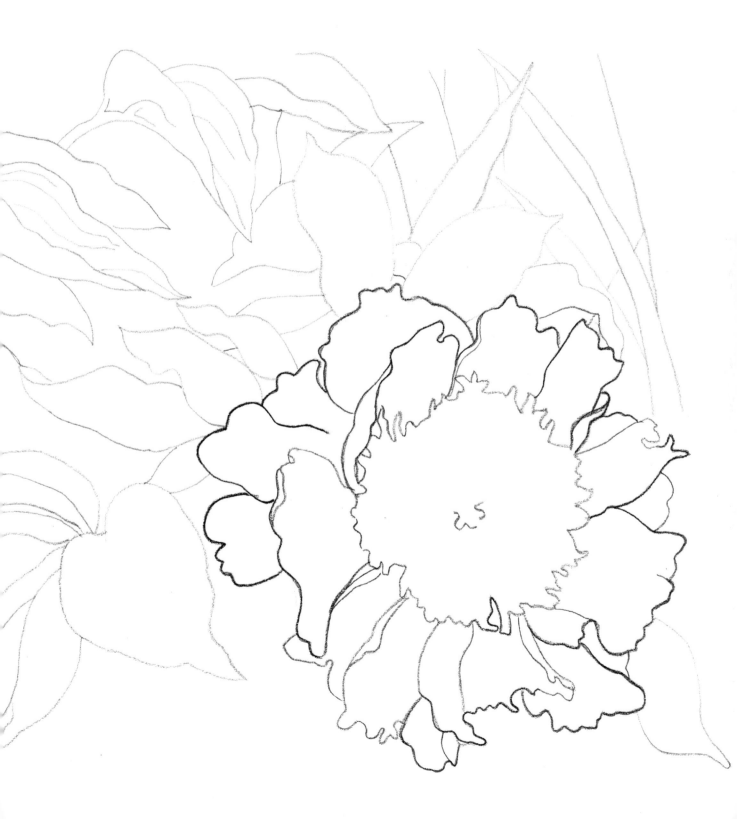

Freckelton's watercolor in its first stages of development. The brief blooming time of the dominant peonies and irises necessitated her establishing them quickly while she could work from the living flowers, painting each bloom completely before going on to the next.

1. After establishing the placement of the peony bush and painting the blossom in the right foreground, Freckelton began work on the bicolor irises, leaving areas of brilliant white paper to bring them forward.

2. She wanted the purple irises to recede, and so she altered her treatment of them, this time laying in rich color and then lifting some of the color off the paper to pull out soft highlights to define form.

3. Next she painted the blue-green leaves of the irises, contrasting their shapes and colors with the deep greens of the peony bush in front of them. This helped separate these elements and create a recession in space.

4. She developed the peony leaves further, emphasizing the directional rhythms of the bush to integrate the overall composition. Finally, she turned her attention to articulating the remaining peony blossoms, positioning each carefully in relation to the painting as a whole.

kelton kept mixing colors from a wide range of tube colors. Once these base colors were dry, she removed all pencil marks and then overlaid deeper tones to establish form and shadow.

I was able to start painting the peony flowers in place as they were coming into bloom. I must admit that, even to me, a single blossom floating on a 4' x 5' sheet of blank paper has a strange appearance, but it reinforces my need for and belief in preparatory works. I know that the flowers will be captured and placed properly on the paper even though they have disappeared from the garden and that when the painting is further along, they will be integrated onto a plant and into a garden space. As I worked on each flower, finding and rendering subtle discoveries in a single petal, I was able to be constantly aware of the intent of the whole picture.

Before I could finish painting all the peony flowers in the foreground, I had to paint the irises because their blooming period would be finished before that of the peonies. Now that I had set a color intensity, a light source, and a scale for the painting with the establishment of some of the more important foreground flowers, it was a simpler matter to draw and paint the irises. I had already drawn the bush and painted the peony flower that thrust in front of the iris clumps, and I had established in pencil the path leading behind the bush to the middleground where the purple iris would be painted.

Developing the Painting

Next Freckelton began to develop the areas adjacent to the peony bush. She decided to introduce irises from another section of the garden just behind the peonies; the bluish-green color of the leaves would help to make a separation between the different plant forms. She also varied the handling of the paint within each flower to indicate the distinct differences in their textures.

In my small oil sketch I had indicated pink iris in the foreground just behind the central bush. Those were the flowers that were growing there when the sketch was made, but I decided that an iris growing in another part of the garden would be a better one for the painting. It was a bicolor of orange-sienna and white. The white would be especially useful to lead the eye to the right-hand side of the painting, as most of the activity in the painting was on the left side. I would be able to get more contrast in both value and color

1

2

3

4

42

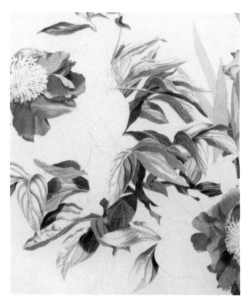

Above, Freckelton used a variety of greens for the individual peony leaves, emphasizing value contrasts to give them volume. Opposite, a close-up of the painting at this stage shows how Freckelton varied color temperatures and values to distinguish each precisely drawn flower from the others.

from these flowers than if I used the pink, which would relate too closely to the focal flowers.

I brought the irises and their leaf fans into the studio, put them in vases, and drew them into the composition. Then I painted them in, leaving as much white paper as possible in the lower petals and toning them just enough to indicate their curving forms and ruffled edges.

I treated the purple irises differently. In these flowers, I left very little white paper because I wanted them to recede slightly. For the most part, these flowers were laid in with rich purples and blues, and I defined their forms by pulling paint off the paper. This was the reverse of the layering process I had used in the foreground irises. I pushed them up in scale slightly from that which I had indicated in the oil sketch, and this had the effect of collapsing the space a little. I didn't want to solve the deep space by simply making things appear smaller and smaller from foreground to background. At this point, I decided I could deepen the space from middleground to background by drawing the wall behind the garden at a less acute angle.

Next I painted the blue-green sword-like leaves of the iris plants. Even though I hadn't finished painting the leaves of the peony bush, I was anxious to see how these different shapes and colors would contrast and relate to the deep, rich green of the plant in front of them.

Integrating the Composition

I began working again on the leaves of the peony bush (bringing them into the studio and arranging them in vases) to establish directional rhythms that would both define the form of the bush and lead the eye up from the lower right-hand corner. The leaves of this bush are very shiny, and I was able to use a lot of white paper in full contrast to the dark rich green of some of the leaves. Painting the foliage in this way enhanced the depth and roundness of the bush and its growth pattern, and at the same time slowed down or reinforced directional patterns that had already been established by the placement and attitude of the blossoms.

While I kept in mind the intention of the whole painting (where I would need to leave a lot of white, rich greens, or intense darks), I drew and painted each leaf differently, giving a great deal of at-

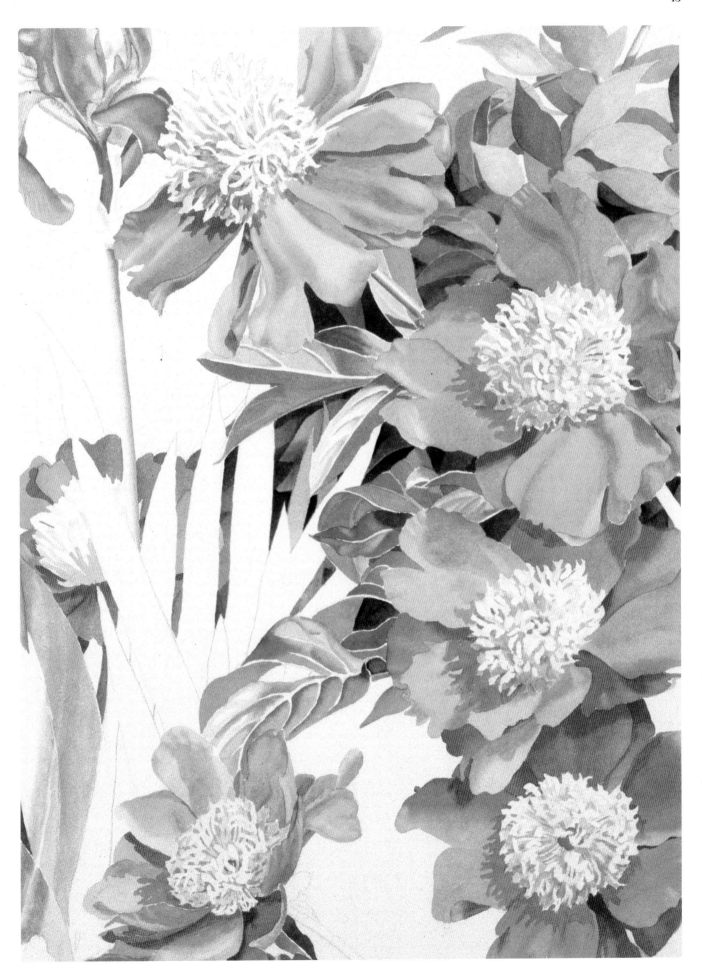

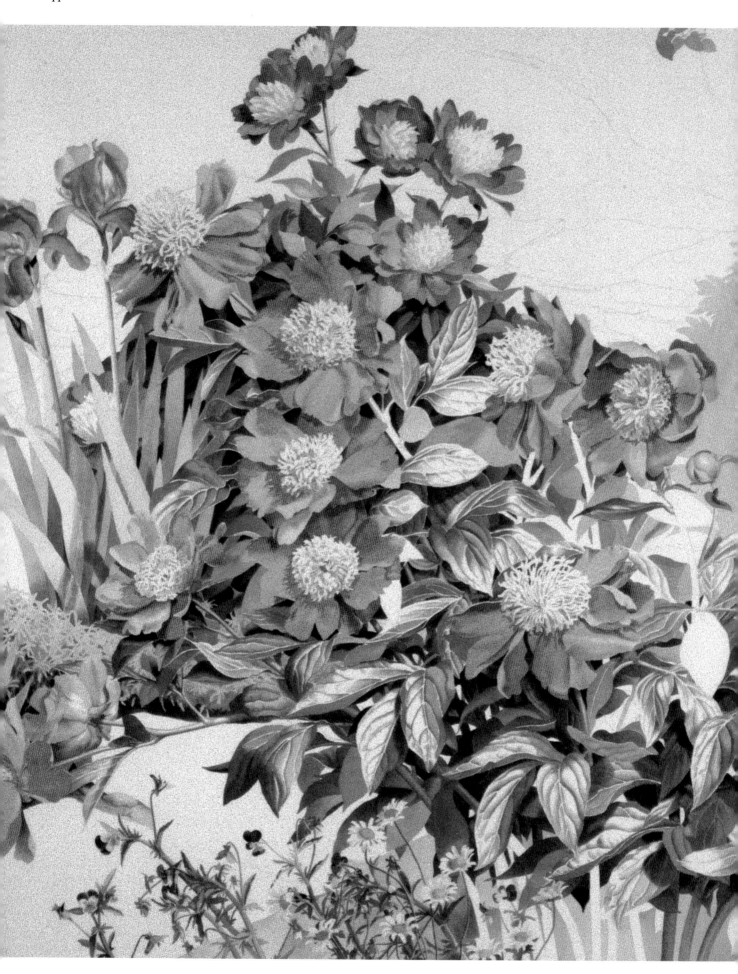

To make sure that the plants in the right middle-ground would not push forward visually, Freckelton painted a soft gray underlay wash in this area. She continued to integrate the composition with the subtle greens of the foliage.

tention to its individual character. I kept the base colors of the leaves to two main colors—sap green and Hooker's light. Yellows, darker greens, and blacks were mixed into the base color chosen for some leaves, but most often these colors were overlaid or were allowed to mix into the wet paint of the basic green. My reason for using just two basic colors for the body of most of the leaves was to integrate them into one bush in contrast to other shrubs in the picture. Each leaf could be handled with differing combinations of techniques without divorcing it from the structure of the whole plant. I used oxide of chromium for the undersides of many of the leaves that were in shadow, but in some instances, especially where the undersides were backlit by sun and would be in front of darker background elements, I used yellows as a base color. I stayed away from the bluer greens in order to heighten the contrast between the background foliage, the foliage of the iris, and the peony bush in the middleground, which I intended to keep in the realm of a rich Hooker's green dark (a bluer green).

In back of the iris on the right-hand side of the painting was a gray-green bush of bleeding heart. It had nearly finished blooming by the time I got around to it, but the plant's shape and color would be a perfect foil for the blossoms in front of it. I decided to draw in the shape of the entire plant and put a subtle gray wash over the whole area. I wanted to be sure that I would leave no whites in it to compete with the iris, or to come popping forward from the shady middle space in which it was intended to reside. By applying this overall gray wash, I would make sure that the lightest possible tone would be automatically knocked back a few shades from the pure white paper; now I could proceed to paint on the gray ground just as I would paint on the raw paper.

Next I was concerned about the treatment of the path, which established a counter-direction to the foreground plants and maintained a separation between the foreground and middleground. But before I could lay it in with color, I had to draw and paint the small, complex plants immediately in front of it.

The drawing and painting of these little plants took much longer than they seemed to deserve, since I considered them more of an embellishment than an important ingredient to the main thrust of the picture. I was anxious to get on to the walk, wall, and water, which would establish the spatial boundaries of the painting.

46

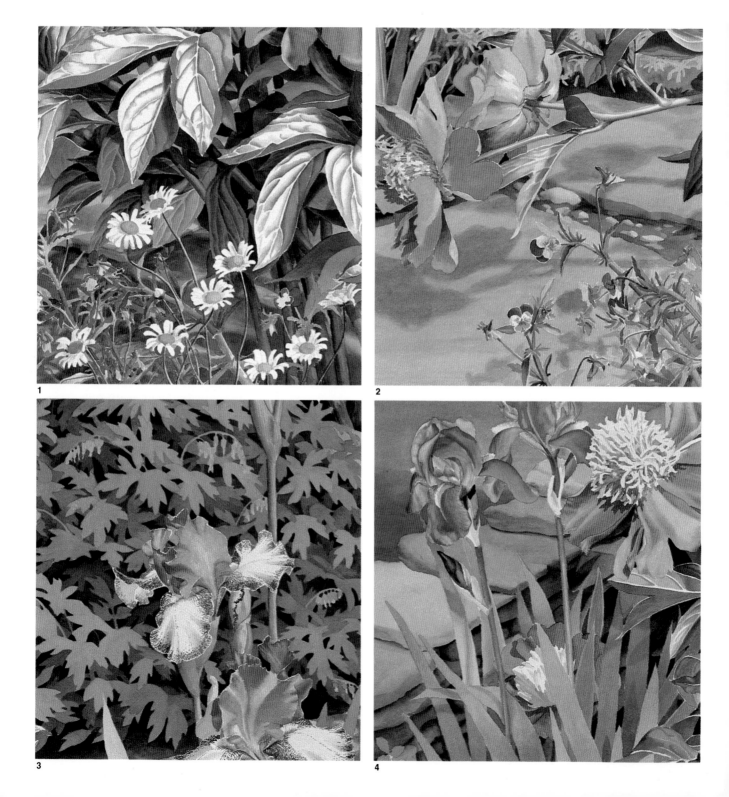

1

2

3

4

1. Freckelton added the smaller flowers in the fore-ground beneath the peony bush. They were difficult to paint, for they had to be detailed and accurate enough to be believable foreground elements, yet subordinated to the dominant elements.

2. The stone walk was painted in warm tones to balance the orange-sienna irises on the right and to pull it forward from the background.

3. The muted contrasts in the gray-green foliage of the bleeding heart helped push it back from the iris directly in front of it.

4. The stone wall was painted in cool colors to make it look shady and keep it in the background.

Finally, I was able to paint in the stone walk. I decided to make the color richer than it was in actuality or in my oil sketch, in order to relate it a little more strongly to the iris standing alone on the right side of the picture. By painting it in the sienna range (warm and sunny), I kept it from relating too strongly to the back wall. I painted the back wall with cooler colors in order to keep it back and to make the whole garden shadier as it receded in space. I treated the back wall (except for its top surface) and the background plants in a more general manner—paying more attention to shape and form and less to detail.

I painted the water in orange-browns, with some reflective color tipped into the wet paint, in order to relate it to the path and to establish a zigzag movement from the lower left (foreground) to the upper left (background). To create the light reflections on the water, I painted them and then sponged them out to release the light—but not the white—of the paper. I gave the farthest shore an overall wash of yellow with a little green, and then I painted the details, working from light to dark.

Completing the Painting

At this stage all the white of the paper was covered except those areas that would be white in the finished painting. Now it was "punch-up" time—time to put the painting up on the easel and stare at it for long periods of time; time to decide whether colors were too intense or not intense enough; and time to determine where there needed to be more or less contrast.

The main problem with the painting at this juncture was that I hadn't made the darks in the back of the garden dark enough. I had kept them lighter, thinking that they would recede better if there were less contrast. But now I decided that they needed to be darker and could be as dense as the foreground and still remain in the back. Only the nearer parts of the garden went from pure white to almost black.

The other final revisions were minor changes here and there: pushing back some of the leaves in the front bush by overlaying a tone of green where there was too much white paper. This change helped to make the rhythm of the plant more flowing and less spotty. I also added a little more dark behind the front white daisies and alternated the intensity of the blue-green iris leaves to accentuate the backward and forward motion.

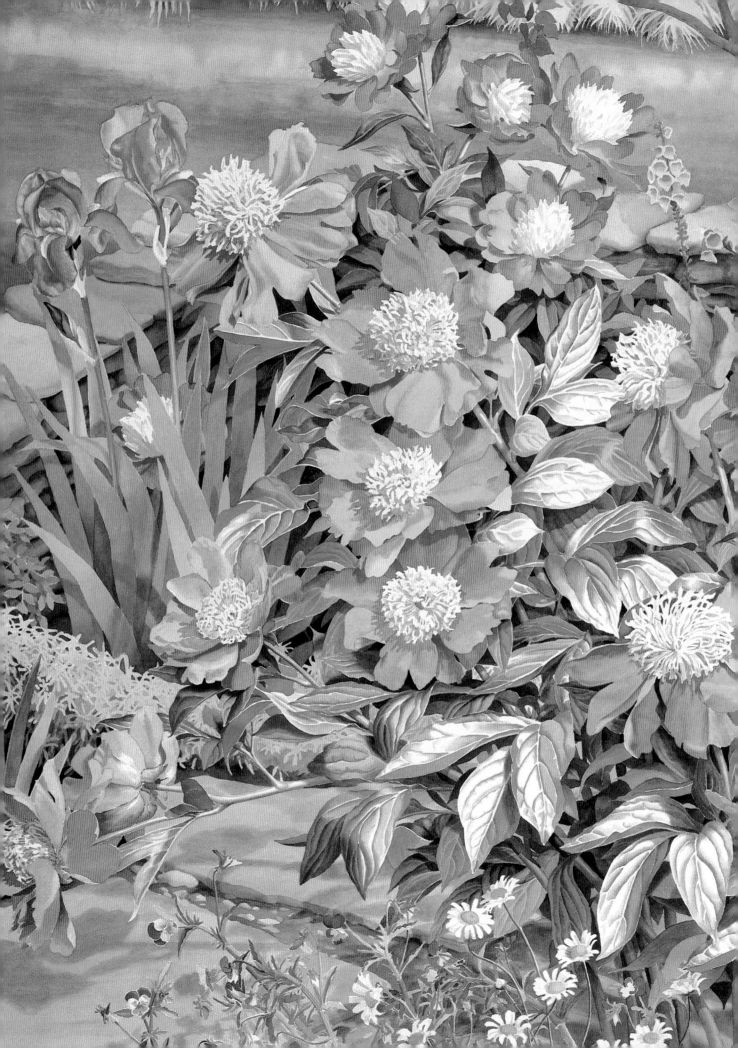

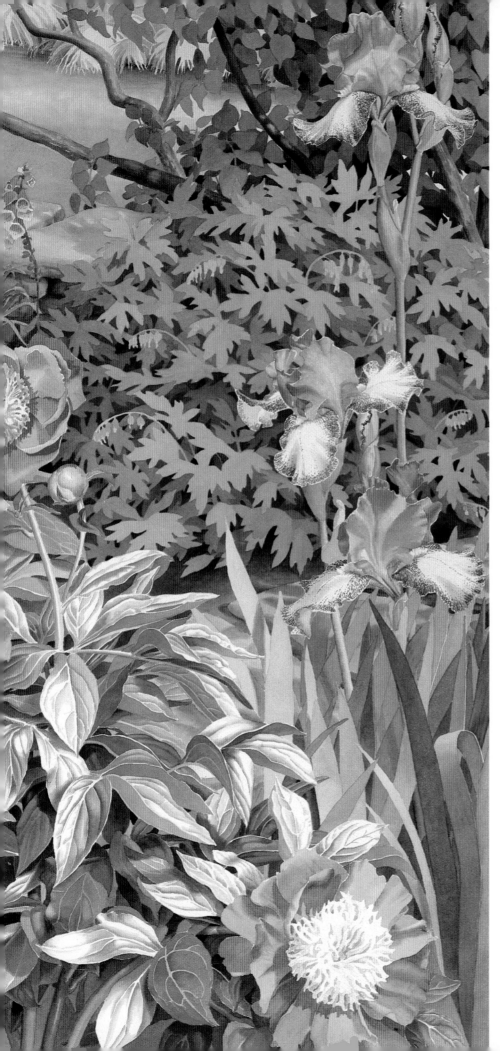

Flower Garden, 44″ x 50″ (112 x 127 cm), 1981, courtesy Brooke Alexander, Inc., New York. Photo: Eric Pollitzer. The key to the success of Freckelton's beautifully orchestrated finished painting is her careful planning and preliminary studies. Having worked out color and compositional problems in advance, she could approach the actual watercolor with the confidence that each individual component would work well in the overall composition.

Part Three

Teaching Workshops

In order to illustrate watercolor methods appropriate for painters at different levels of experience, Sondra Freckelton conducted three teaching workshops, working with individuals who represented a broad range of experience with watercolor. In the first, she worked with a high school student—an intelligent young woman with an active interest in art who was nonetheless a beginner when it came to watercolor. In the second workshop, Freckelton worked with a woman who had no formal art education but who had done several watercolors over a period of years. Freckelton helped her build on the skills she already possessed and correct some of the problems in her current work. Finally, Freckelton worked with a professional artist who had worked exclusively in oils, giving him advice on how to adapt his working methods to the watercolor medium.

In this part of the book, some of the actual conversations that took place between Freckelton and her students are presented just as they transpired. When Freckelton is the only speaker, her words appear in italic type, as before. When her student enters into a discussion, both speakers' words appear in italics, but each person is identified with his or her initials.

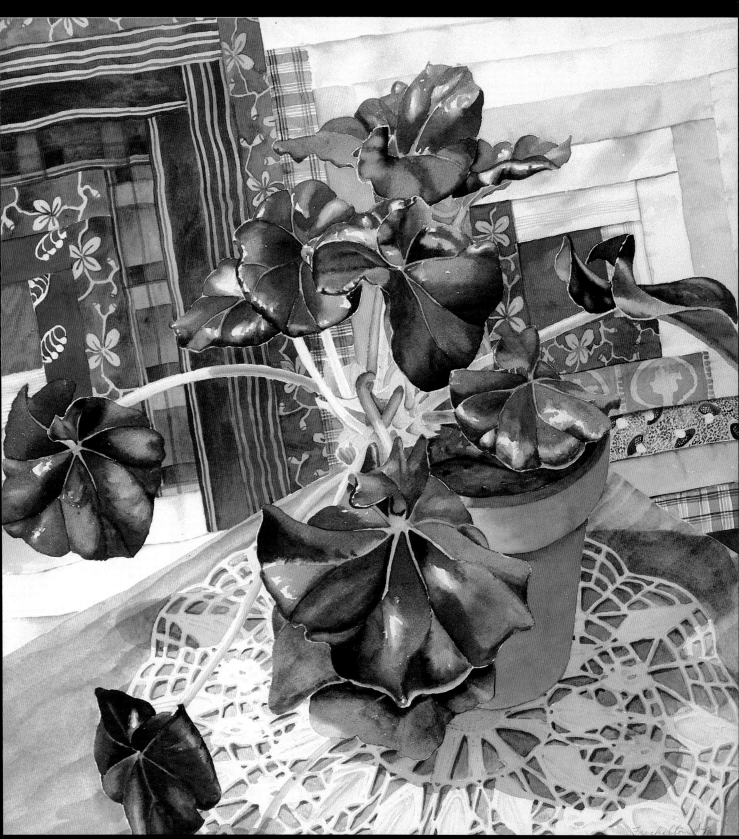

BEGONIA ON DOILY, 20⅜″ x 27″ (52 x 69 cm), 1976, private collection

WATERCOLOR FOR THE BEGINNER

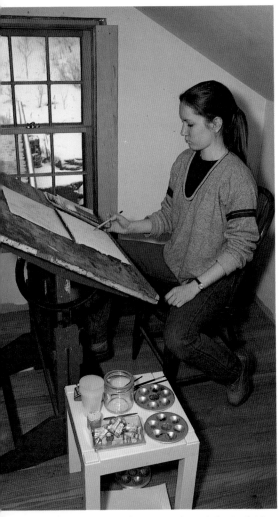

Anne Wilfer began her watercolor painting by lightly sketching in her composition.

At the time of this workshop, Anne Wilfer attended the High School of Music and Art in New York City and had done a fair amount of painting and drawing in her classes and on her own. Although she had had a good general introduction to art in its various forms, she had not had a thorough exposure to any one medium.

Freckelton decided to start this workshop on the farm at Oneonta by covering the most basic information about watercolor—from the conception of a painting to its completion, from selecting materials and subject matter to an understanding of how watercolor behaves and can be manipulated.

Materials

The first step was acquainting Wilfer with the basic watercolor materials so that she would be able to choose those most appropriate to her needs and then learn to use them properly.

PAPER. For her paper, Freckelton recommended that Wilfer use a block of cold-pressed 140 lb watercolor paper. Because blocks of watercolor paper are bound on all four sides with gum binding, it was not necessary for Wilfer to tape, staple, or tack the paper to a board in order for it to regain its shape after being stretched by the water in the paint.

If you do use single sheets at some other time, you have to be very careful to use the correct side. A lot of people don't realize there is a right side and a wrong side to watercolor paper. A sizing has been applied to the correct side to prevent the watercolor from sinking into the paper. Many times there is a watermark in the paper which will help you identify the right side. If there isn't one, you can tell which is the correct side by holding the paper up to the light. The side that is sized will be shinier, the other side duller.

BRUSHES. Control of watercolor paint depends in large part on the quality of the brush used, and for that reason Freckelton insists that students not compromise on that quality.

Next I'd like to show you how to choose a good brush. Dip a watercolor brush in water, pull the water out with your fingers, and see if the brush comes to a good point. It should, if it is a good brush. Now take the brush and press the body of it against your other finger. A well-made brush will broaden slightly but retain its

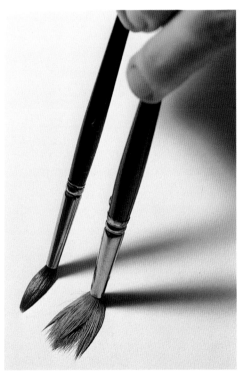

This photograph demonstrates the difference between a good watercolor brush and an inferior one: the body of a good brush should not split when pressure is applied.

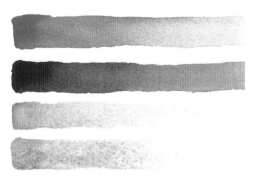

These test swatches show how different pigments behave; some granulate and settle in the hollows of the paper when applied in a wash.

shape and its point, but an inferior brush will separate or split up the middle. When you paint with it, a good brush should hold its point and release paint according to your pressure. It should not split and release all of its paint in a puddle, leaving you wondering what to do with all that paint. A good brush should not only respond to your pressure but bounce back again when lifted. A bad brush doesn't have the ability to manipulate the paint because it has no resiliency. Some otherwise good brushes have too much of a point. These have a tendency to curl over and sometimes will snap back when you lift the brush, splattering the page with little droplets of color.

Wilfer chose a No. 4 and a No. 6 sable brush for her painting.

COLORS. Freckelton explained that the paints are sold in either a liquid state in tubes or a solid form in cakes or, "pans," either of which will give excellent results. On Freckelton's recommendation, Wilfer bought tube colors.

The differences in brands of paint depend on both the manner in which they are manufactured and the natural characteristics of the pigments. Some pigments are easily ground into fine particles that make up a good-quality paint, while others—especially the earth colors—remain grainy, with large particles of pigment remaining suspended in the binder. The actual hue of a color may vary dramatically from one manufacturer to another.

These variations in quality and hue make it essential for watercolorists to test their paints before using them. For this reason, Freckelton suggested that Wilfer keep small scraps of the paper she would be working on to test out her paints. She recommended that her student buy a brand of paint recognized for its high quality and then grade out a small swatch of each color from pure pigment to water on a scrap piece of her watercolor paper. This color chart could then be used as a reference while painting.

PALETTE AND OTHER SUPPLIES. Wilfer was given five plastic trays with 8 cups in each for laying out her colors. Freckelton suggested that she put a small bit of color on the side of each cup in the pans, arranging the hues according to the following color families: one tray would contain blacks and grays; another, the browns; the next would have reds and purples; the next, blues and greens; and the last, the yellow, orange, and ochre pigments. Wilfer was also

given some small cupped dishes for mixing up large amounts of color when needed for painting large washes.

Freckelton also asked her student to have available a vinyl or acrylic gum eraser (the kind used for drafting, so that erasures would not mar the paper), pencils, and a small natural sponge.

🖌 Painting Exercises

Freckelton had her pupil complete four painting exercises before beginning work on her still life watercolor. Each exercise was designed to familiarize Wilfer with some basic characteristics of watercolor and suggest ways of using the medium to advantage.

LAYING A WASH. A large, evenly painted shape or background is often difficult for the beginner to paint in watercolor. Freckelton pointed out that the two most common causes of failure are that the artist doesn't prepare enough paint to cover the area and that he or she strokes the area too many times with the brush.

To learn the proper application of a wash, Freckelton had Wilfer tilt her horizontal work surface to a 30-degree angle so that gravity would help the paint flow down the paper gradually. Next Wilfer mixed up a generous amount of one color, making sure that it was mixed thoroughly and evenly.

Following Freckelton's instructions, Wilfer loaded her brush with the paint and stroked it in a horizontal line across a piece of scrap watercolor paper. As soon as that line was painted, she dipped her brush in paint again and moved it down and repeated the same stroke, just along the bottom edge of the previous line.

Don't apply too much pressure to the brush. You want the paint to flow naturally down the paper; use your brush simply to supply more paint and guide the liquid down the page. Don't paint up over your previous line. Always place your brush in a position to catch the flow of the paint, adding a little more paint to it when needed to keep the flow at the same rate as you lead it across the paper.

Wilfer refilled her brush and continued to guide the wet paint down the paper in horizontal bands. Once she reached the bottom of the area she wanted to paint, she squeezed the excess paint out of the brush and stroked the bottom row again lightly to pick up the pool of paint at the bottom.

Wilfer's first painting exercise was laying a smooth wash: stroking across the paper from left to right, she renewed the supply of pigment on her brush before beginning each new stroke, taking care to blend the new application of paint with the preceding stroke.

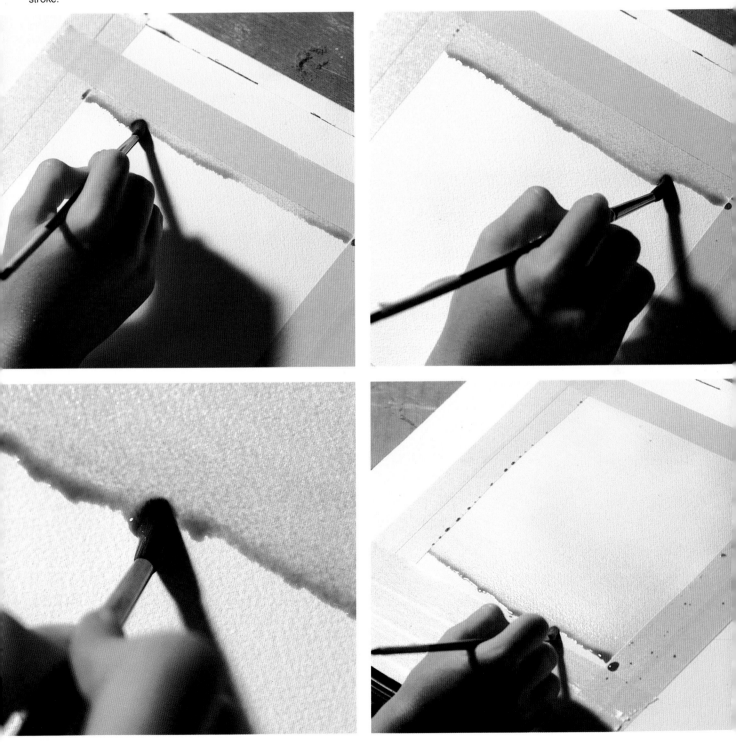

56

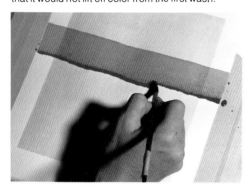

Next Wilfer laid a second color over her first wash. It was necessary to brush the new color on quickly so that it would not lift off color from the first wash.

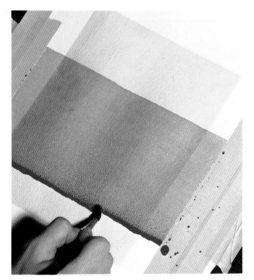

Don't worry if that last stroke seems lighter than the others; eventually the paint will seep down and even out the tone. Let the wash dry in this same tilted position. If you turn your paper back to a more horizontal (to another) position at this point, the paint will begin to flow back toward the new direction of gravity and dry unevenly, leaving furry-looking paint edges where the wetter paint ran into the dry.

OVERLAYING A SECOND COLOR. After Wilfer's first wash was dry, Freckelton suggested that she paint a wash of a second color over a portion of what was already on the paper.

I want you to see the appearance of an overlay. One color sitting over another has an entirely different complexion and luminosity than it would have if the two colors were blended together on your palette and then applied. For this exercise, draw a square about three inches below your original wash, which is now thoroughly dry. Make it large so that it will cover some bare paper as well as a portion of your first wash area. In this way you'll be able to see the pure color of both wash applications and the color they combine to make in the overlay. If you follow the same procedures for this overlaid wash as you did on your single wash, you will have no trouble. Hold your brush lightly and flow the paint quickly so it has no chance to soak into the next color and cause it to lift.

WET-IN-WET PAINTING. One of the classic watercolor techniques is called "wet-in-wet," which means, as the names implies, that the artist paints on wet paper or into a color that is not yet dry. Depending on how wet the paper is, an artist can achieve effects that range from soft edges of a definite shape to random patterns of crawling paint. With practice, it is possible to learn to anticipate these various results and use them in painting.

At Freckelton's suggestion, Wilfer wet an entire sheet of paper on a small block of her watercolor paper and painted various colors on it to see how they would react to the wet surface. As the paper dried, Freckelton then suggested that her student lift sections of paint off the paper with a sponge and also paint more color on the drier shapes.

You will use these kinds of manipulative techniques a lot as you paint because they take advantage of the natural characteristics of the paint. Once you learn to manipulate the paint and anticipate

Freckelton had Wilfer practice painting wet-in-wet in order to become familiar with the way watercolor be- haves when applied to a wet surface.

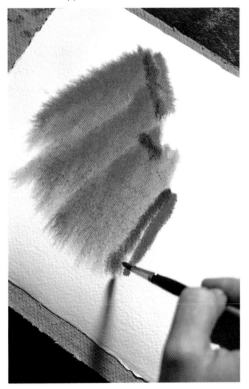

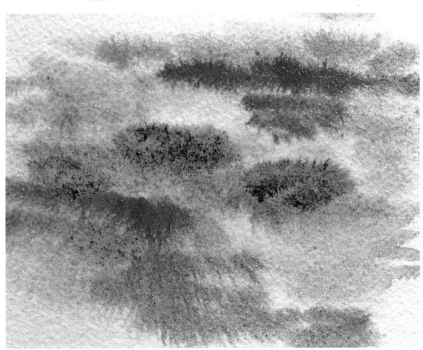

Anne Wilfer practiced lifting shapes from wet color, using both a dry brush and a sponge.

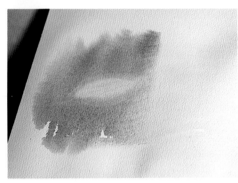

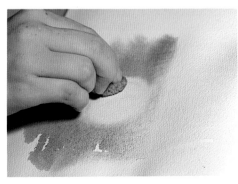

its reaction to both wet and dry surfaces, you will be in control of the medium.

Wet your whole page and try tipping some bright color into it to get an idea of how water behaves in this circumstance. Paint a portion of the page with a medium color tone, then try taking some pigment off by rewetting part of that area with water and lifting with a dry brush. See what kind of lighter spot you get, and whether you like the interior edges better when done this way or as before, when you did the same exercise with a sponge. Try manipulating the paint in the center around the lighter spot until you understand how to get the interior edges to dry with a look you are happy with.

SOFT AND HARD EDGES. The final exercise Freckelton asked her student to undertake was designed to show her how she could control the degree of sharpness on the edges of the objects she would be painting.

Draw a shape, then paint the area wetly to your lines. Let the paint dry naturally on all but one edge. Try to manipulate the paint on this edge while it is still wet. See how smoothly you can grade it out with pure water, using your brush wet and then dry to change and soften that edge. You'll find the natural edges will dry crisp and sharp. You'll see that whenever wet paint meets dry paper, pigment collects and creates a dark, hard edge; but whenever wet paint meets wet paper (or paper that is moistened while the paint is still wet), a softer edge is created.

❧ Choosing the Subject

Establishing the subject matter for a painting is a very important and sometimes difficult part of the painting process. With a universe of both real and imagined subjects to choose from, making the commitment to just a few objects can be difficult for an artist. To surmount that problem, Freckelton begins many of her workshops by asking the participants to bring with them one object they particularly like. Any portable object that a student finds visually interesting can be considered. The important thing is that the artist examine that object, either by itself or grouped with others, and try to verbalize exactly what it is about that object he or she finds interesting.

Freckelton's final exercises for Wilfer consisted of
learning to manipulate the paint successfully to
create soft and hard edges.

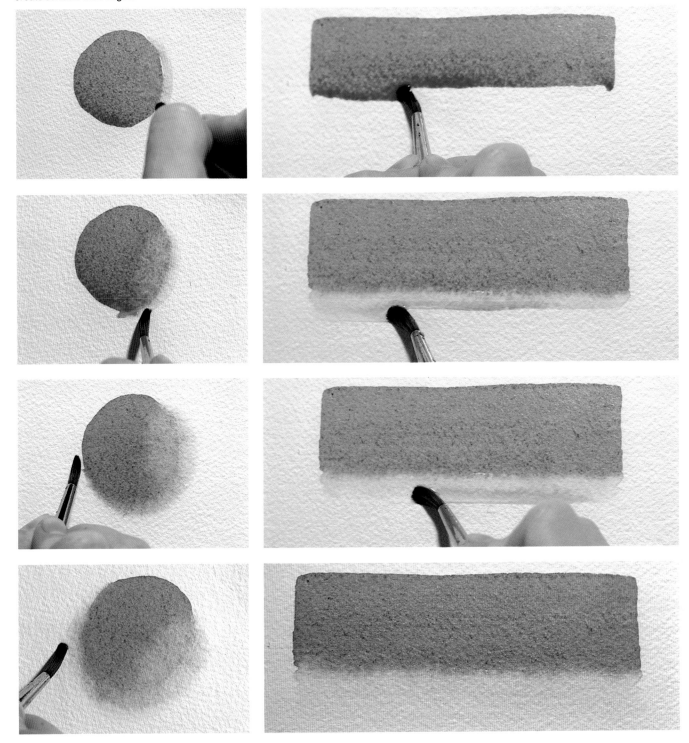

Anne Wilfer's setup not only reflected something about her life but also provided an interesting assortment of textures and subtle tones for her to render in watercolor.

After you make your setup of objects, I'd like you to talk to me about it. You'll find that you will pick out the things that are the most interesting about that object or group of objects when you begin to verbalize. I'd like you to do the same thing when you communicate visually.

For this particular workshop, Wilfer brought along a brand-new pair of running shoes that she found visually interesting and representative of some personal aspect of her life. She arranged these on a table in the studio, with the shoes resting on a sweat suit and with athletic socks draped in and around them.

Aside from the fact that the objects Wilfer chose were very much a part of her own world, she thought that the softness of both the color and texture of the sweat pants and socks would be interesting to paint. A painting in many shades of neutral colors would allow her to concentrate on the subtle textures and tones which she associated with the medium of watercolor. She explained to Freckelton that these objects, combined with the contrasting crisp whites and high color of the new running shoes, presented a challenge that she was anxious to meet.

🎨 *Making a Pencil Sketch*

With her subject set up and her supplies gathered around her, the next step for Wilfer was to make a preliminary drawing of the sneakers and sweat suit so that she could be certain of her painting composition.

I'd like you to work up a composition with pencil and paper, working from your setup, and try to clarify your ideas. This preparatory work is important. The technique of painting is only one element in the making of a good painting. If your ideas are muddled, your composition unclear, or your drawing unskilled, beautiful paint will not save the watercolor.

I can look at your actual subject and see some very intriguing possibilities in the setup, but I would like you to give me the opportunity to see what you are seeing. Pick out the things that are important to you and make them appear more important on the page, exaggerate them a little. Tell me something about your subject and make me see that something.

I like the way you have placed your objects on the paper. I also like the scale of the shoes in relation to the size of your paper and

Making a pencil sketch enabled Wilfer to clarify her composition before beginning to paint. Her drawing has an enhanced feeling of movement (see diagram, opposite page) that is appropriate for her subject.

The diagonal thrusts of the shoes and socks (represented by large arrows) are exaggerated, and the colored designs on the objects (dark arrows) act to reinforce these major movements. The laces create small, active counter-movements that "travel" over, through, and around them.

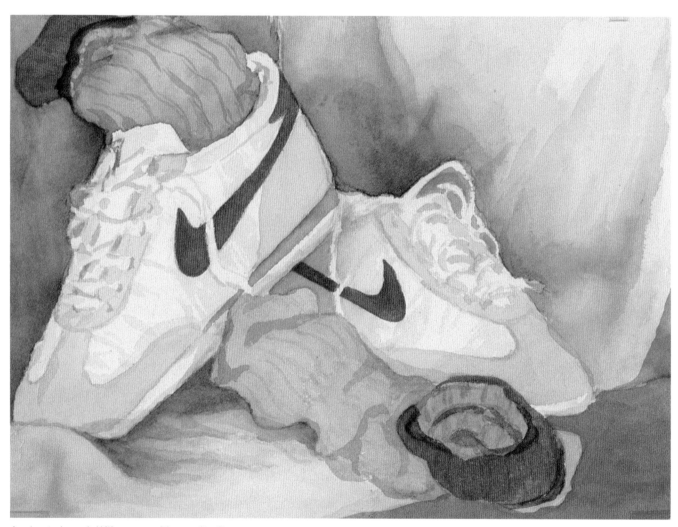

A color study made Wilfer aware of the need to distinguish white areas from the subtle grays of the clothing and to integrate the strong reds well into her overall composition.

the open parts of the picture. You have put more travel and rhythm in your drawing than is actually in the setup you are viewing. The shoes look a little precarious, again adding to the brisk pace of your drawing, most appropriate to the subject.

Making a Color Study

Emphasizing again the importance of preparatory work for watercolor, Freckelton next had her student do a small watercolor study of the still life composition. This small-scale, loosely painted study would give Wilfer a little more experience in handling the brush and paint, and it would help her establish the composition of colors and values in the final painting.

Because of the sparsity of bright color in relation to the many subtle grays in your subject, the placement, drawing, and organization of the color is going to be crucial to your final watercolor. Along with some crisp whites, the colors will begin to set up important movements and rhythms of their own that will have to be integrated with those you have already established in your drawing. A small color sketch (really a shorthand visual note to yourself) would be helpful before beginning the painting. While you are doing your color sketch, keep in mind how your lights (whites) are going to work and how your darks are going to work, as well as what your color is going to do. Now is the time for big decisions and changes, since you should not be concerned about the handsomeness of a working sketch. Your concern should be, in this instance, whether you work out all the major color and tonal information to your own satisfaction.

Looking at your color sketch, I feel the reds are so strong that your whites are going to have to be strengthened by darkening the tonality of your grays. Squint your eyes and look at the sketch. It helps you see what is happening in the tonalities without being distracted by the objects. The whole tone of the sketch is so light that nothing really appears white. Pick out the places in the painting where you want pure whites and then tone the rest. This will give the objects more volume as well. For instance, making the white shoelace pick up and follow the curve that zooms around the sock gives that sock volume and begins to define the form and space. When you pick out your whites, try to make them perform more than one function. The fuzzy sock is made softer and more

relaxed by the crisp-edged white shoestring flipping over it—work the color sketch up just as far as you need to. Once you begin working on the watercolor, if you are unsure of an area you can go back to the color study and solve it there before you proceed further on your painting.

☙ Beginning the Painting

With all of the valuable preparatory work behind her, Wilfer moved confidently to her watercolor block to make a light drawing of the still life arrangement. She first superimposed proportionate grid lines on both her preliminary pencil drawing and the blank watercolor paper. Using these grids as guides, Wilfer made a light pencil indication of the sneakers, socks, and sweat pants.

Sondra Freckelton: Now you are ready to start your painting. What kind of scale do you want to work in? The preliminary drawing is small, and therefore the shoes in it are smaller than life-size.

Anne Wilfer: I think if I put it on the larger sheet of paper, it would have to be larger than life, but I was always told not to do that because it would exaggerate the subject.

SF: Well, do you think that is a good reason for establishing a particular scale for your painting? Were you ever given a good reason for not painting an object larger than life?

AW: No, I wasn't. I was just told that it was wrong.

SF: So in other words, it's a rule given to you which doesn't seem to have any reason behind it—as far as you can see.

AW: Yes.

SF: Well, what do you think about the scale in view of your intentions for the painting?

AW: Well, I want to make the shoes important. They are the most important thing on the paper, so they would have to fill up the space. So, I guess if I did put them on the larger sheet of paper, they would have to be enlarged more than life-size.

SF: Okay, but are you going to enlarge them more than life-size just to fill up your ready-made paper, or are you going to make your paper fit the scale of what you have in mind? Do you think they have to be a little bit larger than life, life-size, or smaller than

Wilfer followed Freckelton's suggestion that she establish her tonal values in the gray sweat pants and socks by working from light to dark.

the actual shoes in order to get across your ideas about them?

AW: *A little larger.*

SF: *I think you are right. I think that by making them a little larger they will look more life-size. Smaller shoes would look miniaturized and they wouldn't be as convincing or as strong an image. I don't think you want to make them too large so that they become a kind of funky image and interject completely different intent. But with the slight enlargement, I think you will get across the kind of impact you feel about them. Thinking about the scale, rather than going by a rule, is always the best course. What you want to make these shoes be and the image that you want to get across are the important things. And so the scale will have to go according to what you feel about the subject. If you had a lot of little movements and you wanted something small and quick, you might make them a little under life-size. In other words, that might dictate your scale. That kind of thinking dictating your scale to you makes more sense than just following rules of dos and don'ts.*

Once the scale and placement are established on your larger paper, you will want to draw your subject more completely from your setup in order to give yourself a more informative guide to begin painting.

You have a general idea of where you want the shoe on your page. Now you want to look again at your subject and give the shoe some nice lines. Even if you were to start by painting the cloth in the background, behind the shoe, the edge you would leave would be the line of the shoe. Every edge you leave is going to show up. You have to think about painting in watercolor a little differently than you do when you are using opaque media, which can be changed.

I would suggest that you start this painting by laying in some of your light and medium gray tones. This way the painting will develop more slowly and give you a chance to make further visual decisions.

In your color sketch, the background (the sweat pants) is a light gray tone with no pure whites. Lay those parts in and work up from light to dark.

The minute you put a mark on your paper, your painting begins to demand certain considerations. If you are unsure of changes

you think you may want to make, put in some more of the areas that you are sure about, so that your painting itself can help you decide whether to make those changes.

You have to think consciously when you are first starting out— later on a lot of the decisions become second nature, but you have to learn how to look and how to interpret first, and that takes some very conscious effort.

Developing the Painting

Before you paint any further, I want to talk to you about the way you are laying out your colors. Because you have put a little drop of pigment in the middle of your mixing pans, and then mixed your water in as you go, you are getting a lot of marks that are not necessarily intentional. You are not getting a good flow of color. I'd like to suggest that you try putting your daub of paint higher up in your pan so that you have the dished part to mix the correct amount of pigment and water; this way you can use it as wetly as you want to and cover a larger area without constant remixing. If you have to keep remixing while painting one area, you are taking your eyes away from your paper and letting some places get too dry; this distracts you from your thinking process and detracts from the liveliness of your painting, and it also creates accidental brush marks where the wet paint overlays the dry.

Before painting some of the larger areas in your painting, you may want to turn your block so that the paint flows in a more convenient direction (away from the more complicated shapes). Immediately after you've laid in the toned shape of the sweat pants, you can use your brush or your sponge (dip it in water and dry it slightly) to make the shape of the lighter areas in the folds. While your gray paint is still wet, draw the brush or sponge across where you want the tone to be lighter.

In some places where you are laying a wash that must be absolutely smooth, you can wet or sponge the whole area before applying your paint. After sponging, let the paper almost dry—or at least wait until the bumps go out of the paper—and then lay your wash. The sponging will take out some of the lines or spots you might have made by erasing or fingering the paper.

You have to wet your paper before you can remove dried paint

Wilfer needed to define the ribs of the socks without their losing the appearance of softness.

with a dry brush. This is a satisfactory method for cloth or parts of the painting that have a soft look.

Before applying your strong red, which has a tendency to move and mix when another color is overlaid, I would suggest that you apply your dulling color—your shading and shadows, whether in a complementary color or a gray—first, so that it will lie underneath the red. This is one of the reasons I suggest you lay out a full palette of colors—even though your painting appears to be confined to just two primary colors and some neutral tones. In addition, the need might arise for introducing color into the wet neutral tones.

Bleeding is another problem you have to be concerned about—that is, when the paint moves from where you have applied it into another area of the paper. Sometimes bleeding occurs when you paint one color over another, and at other times it can occur when you lay one color adjacent to another color. You have to be especially concerned about both kinds of bleeding when you are working with red. It has a tendency not to stay where you put it, and it will rush to bleed into an adjoining wet area. Most of the other colors you are working with in this particular painting will stay where they are applied. Often now, because I have done a great number of paintings, the brilliant reds are among the last colors I put on the paper. That is one reason why it is so valuable to have a color study and all your other references. With your studies and the subject before you, you can paint other things and anticipate the function and look of the reds.

Try to keep your paint really wet when working on the soft objects (socks and sweat pants), and tip in colors where you want them and let them fuzz out into the wet body color. Look very hard at the subject before you start, so that you design your lines and shadows handsomely and at the same time define your form. Try to create a strong contrast between the hard edges of the shoe and the softness of the sock.

You have a nice shadow coming across the ribbed part of the stocking. Try laying the shadow in quite darkly and then rinsing out your brush, drying it, and pulling the light rib indications out of the wet shadow color. That method will maintain the soft look of the socks and the continuity of the shadow. Sometimes the paint will begin to close back in on a pulled-out area, especially when it

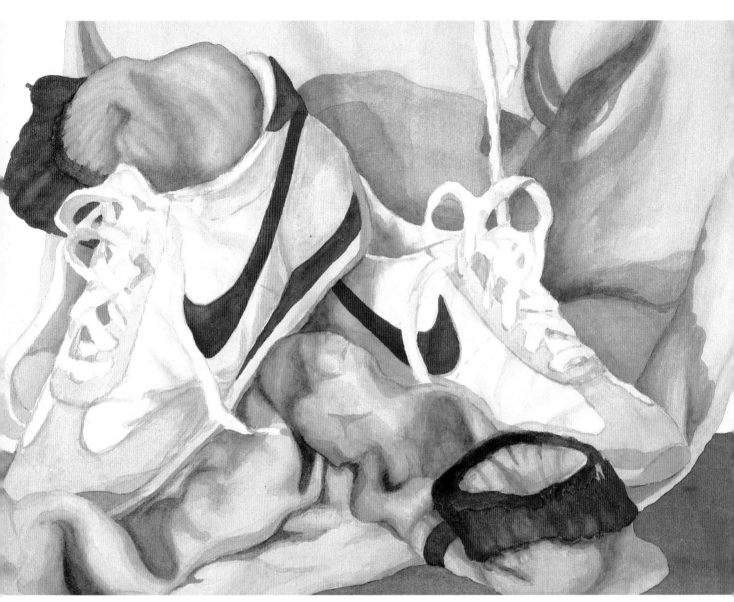

Anne Wilfer felt the blue on the running shoe was too strong.

She gave the top sock more volume, and this helped to balance the strong blue.

Strengthening dark areas next to the whites created more emphatic contrasts.

Anne Wilfer's finished painting successfully contrasts crisp and soft textures, and it plays strong reds and clean whites against the more subtle tonalities within the gray clothing and socks.

is very wet. So you have to keep your eye on it and repull those areas. You might then decide that some of the ribs need darker lines next to the lighter areas you have just pulled out, so while the area is still just damp, you can stroke a darker line in and let it blur itself slightly. There is a lot of manipulation you can do to give the clothing a soft appearance overall.

✒ Completing the Painting

With all of the basic areas of the painting filled in, it then became necessary to stand back and analyze the general appearance of Wilfer's watercolor.

SF: Once you have got everything established lightly on the page—you have to get very brave and start putting in some real darks and some brilliant color. Mix a good amount of red so that your pigment is well suspended; don't use the paint too dry so that you have to smear it on, because it will block the paper and lose its brilliance. Mix enough pigment in the water so that the color seems brighter than you need. If the pigment is suspended well, it will dry lighter than it appears when it is first applied.

Now that you are just about finished, let's put the painting up and look at it awhile. Do you see any areas where you would like to do something more to bring it all together? Do you see anything that bothers you?

AW: Maybe down in the foreground some of the shadows are not dark enough. Also, that blue sort of bothers me.

SF: I think the problem is the relationship of other areas to the blue, and not the blue itself. I think by giving the top sock more body, as you did in the one on the bottom, you will make the blue sit back more. Also, some places next to the important whites need to be a little darker to make the whites work more strongly, both with and against the color.

Other accents were painted in around the paper in an effort to "punch up"—or add to—the forms on the page. The paper was then allowed to dry thoroughly before Wilfer decided that the painting was finished.

INTERMEDIATE WATERCOLOR WORKSHOP

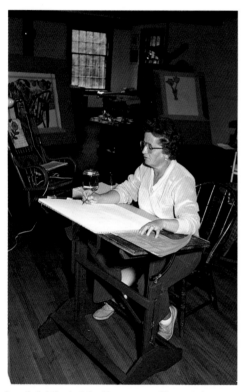

Ingalls lightly sketched her composition onto her watercolor paper before beginning to paint.

For this workshop, which is geared to the watercolorist at the intermediate level, Sondra Freckelton chose to work with her good friend, and sometimes model, Irene Ingalls. Ingalls is typical of the hundreds of serious amateurs who have attended Freckelton's workshops and who have submitted their work to competitive exhibitions similar to those the artist has judged. She has done some watercolor painting but is ready to improve her skills and her understanding of the medium. The workshop was held in the second-floor studio of Freckelton's upstate New York farmhouse.

Most amateur painters, people who paint for enjoyment in their spare time, have been exposed to the many techniques and tricks of paint application but have not had the opportunity to learn good solid fundamentals of preparing for and executing a watercolor painting. Most need more drawing practice and an appreciation of composition, with particular attention to scale and spatial relationships. It takes much more time to execute a watercolor than it does to draw and compose it, yet most amateurs pay very little attention to the "skeletal" structure on which their painting is built, laboring instead over the cosmetic brush work.

I would like, in this workshop especially, to pay particular attention to the thought and skills that must be considered before and during the watercolor process.

Materials

Instead of giving Ingalls a shopping list of supplies to buy, as she did with Anne Wilfer, Freckelton asked Ingalls to simply come with the paints, brushes, and paper she was accustomed to using; she would discuss those with her before Ingalls began to paint. Ingalls brought a good range of Winsor & Newton tube colors, an assortment of brushes, two sheets of smooth-textured watercolor paper, and a combination palette and mixing tray.

I have some suggestions about your materials that might be helpful to you in this and future paintings. Your colors look fine. Your paper, however, is more suited to your complex landscapes, where most painted areas are broken up into very small detailed sections. In your still life paintings, where there are much larger areas of unbroken color and fewer small details, you would find it more advantageous to use a paper with more tooth. That will hold more color in the large, plain areas and will be more receptive to a smooth-looking wash.

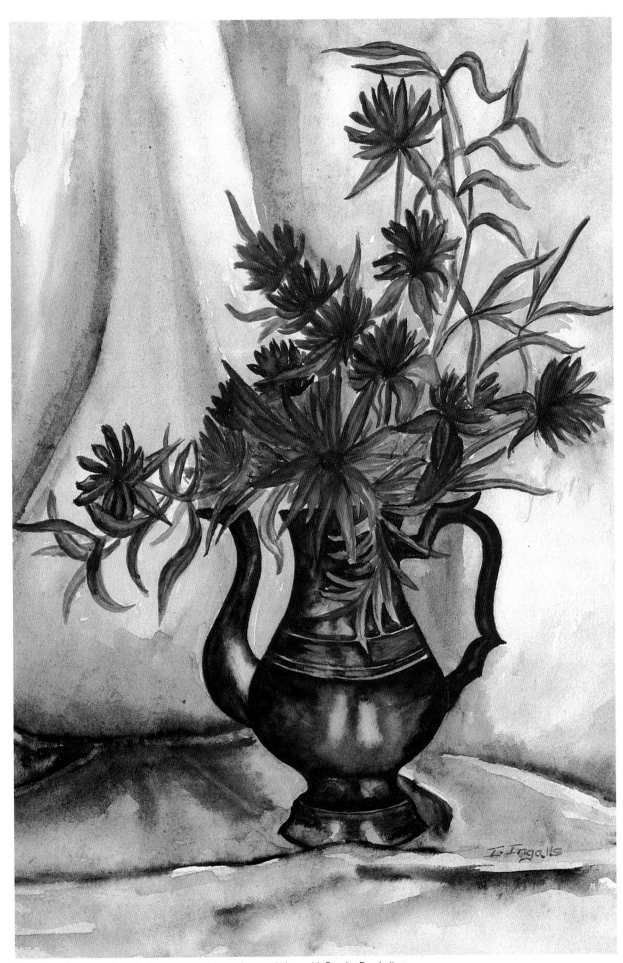

This watercolor was painted by Irene Ingalls prior to her workshop with Sondra Freckelton.

Following Freckelton's advice, Ingalls switched to a block of 140 lb watercolor paper with a medium tooth.

Your favorite no. 10 sable brush is in good shape, and even though it is ten years old, it still has a good point. It is the best brush in your paint box, and that may be the reason you rely on it almost exclusively. All your smaller brushes are in rough shape. Get a good no. 6 or no. 4 brush. If you find that your favorite brush is still the no. 10, get an extra brush of the same quality and size so that you will have a clean brush ready when a quick cleanup, change of color, or other alternate situation arises.

The other improvement I might suggest has to do with your palette and mixing tray. What you have is one small tray with a place for seven colors and two small mixing areas. That tray might be adequate for sketches in the field where reducing the weight and bulk of supplies is an advantage, but I would think that limiting yourself to one tray would be an unnecessary handicap in the studio. Get yourself some sectional dishes or divided, cupped tins so that you can lay out a full-ranged palette and have the opportunity to use any color you may need quickly and immediately. The disadvantage of having to scrabble through your box looking for the right tube of color (especially while in the process of painting an area) can and should be avoided. Give yourself room, lay out your palette and materials so that everything is easy to see and to reach, and use a large, sturdy container for your water so that the water can be kept clean for mixing with your colors and rinsing your brush without your constantly changing it.

After borrowing additional plastic trays for her palette and making sure that she also had a natural sponge, pencils, and an eraser at hand, Ingalls was ready to begin painting.

Painting Exercises

Just as in the beginner's watercolor workshop, Freckelton had her student do exercises in laying a wash, overlaying a second color, painting wet-in-wet, and painting soft and hard edges (see pages 58–59). In this workshop, the exercises performed a dual function. They served to familiarize Ingalls with her new materials, and they also gave Freckelton an opportunity to see where Ingalls might need some special instruction, to observe the degree to which she understood the natural behavior of the medium, and to

Ingalls had been taught how to paint her colors on dampened paper and allow them to blur, but in Freckelton's workshop she would also learn other ways of manipulating watercolor to get different effects.

determine the progress of her painting skills. An interesting discussion followed the wet-in-wet exercise.

II: *When I was taught to make a watercolor in school, I was told to soak the whole page and then blur the paint on.*

SF: *Well, to me, that is only one of many methods. We will use that method in some areas in this workshop, but I would like you to try to use many different methods within this one painting, letting the result you want dictate the method you use to obtain it.*

II: *I was taught to leave white areas so that colors didn't run into each other.*

SF: *I would prefer that you leave white for other reasons as well. You have to plan your whites. Sometimes you will want the paint to meet and run, to meet and leave a dark edge, and sometimes you will want to leave crisp white edges between your colors and shapes. But you will want to leave those edges for the sake of your composition, not for the sake of the technique.*

II: *That watery technique, that way of painting, was all blurred, and all I ever got was an effect.*

SF: *Yes, I think effects can be good tools. Effects, techniques, and ways of manipulating the medium are important to learn, in order to get the result you desire. But the technique is not an end in itself—it's a means to an end. That particular effect may come in handy from time to time, but it is only one method, and the time and place for its use must be dictated by your needs and the needs of your painting in order for it to be employed.*

None of these exercises, nor the procedures that will be talked about or demonstrated in this workshop, should be looked upon as the way to make a watercolor. Each is only one way, and they are offered so that you can use them if and when they are helpful to you.

❧ Choosing the Subject

Since Freckelton puts as much emphasis on thinking and seeing as she does on the act of applying paint to paper, she had a general discussion with Ingalls about what objects she wanted to paint and why.

II: *Sometimes it's not easy to explain why I like what I'm drawing.*

Ingalls' rough pencil sketch of her composition.

It just looks good. I think that's a hard thing to explain, why I've chosen objects and set them up in a certain way.

SF: *Some of your reasons may only reveal themselves to you as you begin to draw your still life. Then you might exaggerate something you have discovered in order to make it more important, or you might want to play it down and make it less important so that it would not be obvious or overbearing.*

II: *There are no rules of how to set things up in a certain way?*

SF: *No. If there were, then everyone would do the same painting, and we wouldn't need paintings, because once we saw one we would have seen them all. Everyone's vision is a little bit different, and that difference is what makes your painting interesting. What you see there and what I see there are two different things, two different communications.*

With that, Ingalls started gathering objects from around Freckelton's studio and home that seemed interesting to her. She selected objects with simple, uncomplicated shapes and patterns so her painting would not be cluttered with a lot of things that were difficult to paint. She finally selected a begonia in flower, a cookie cutter, an enameled bowl, a green glass vase, and a red cloth, which she arranged into a still life composition on a table near one of the windows in the studio.

Ingalls then described to Freckelton what it was that attracted her to these particular objects, why she arranged them the way she did, and what aspects of the scene the painting should emphasize. She wanted to bring out the delicacy of the begonia flowers, the pleasantly rounded forms of the cutter and bowls, and the intriguing cast shadows on the table.

🍵 Making a Pencil Sketch

As she had done with the student in the first workshop, Freckelton urged Ingalls to make some quick sketches of the still life setup on a piece of scrap paper.

I'm just going to give you a sheet of ordinary lined writing paper, a scrap piece of paper in which you have no "investment." I want you to make some framing rectangles on it. Just block in where things are in relation to one another and to the shape of your rectangle. Don't try to draw flowers, leaves, vases—just block in

the locations of objects and see how you want to fit them on your page.

In Ingalls' first drawing the objects were placed in the center of the rectangle with a great deal of unplanned space surrounding the composition on all sides.

Pay as much attention to the spaces between objects as to the objects themselves. Think of these spaces and the spaces from the objects to the edges of your rectangle as solid shapes in your composition.

Once your objects are working in a good relationship to one another, try changing the shape of the rectangle you have drawn around them. Try pushing one side closer or moving another edge farther away from the objects until you begin to perceive the placement of the edge of your composition as a working element—for creating space, direction, tension, an interesting tangential relationship, to name a few possibilities. Find a reason for your format and use it to the advantage of your composition.

After she and Freckelton had evaluated the strengths and weaknesses of each of her initial sketches, Ingalls tried some compositional changes and was able to arrive at an arrangement that would make an interesting and effective painting.

Making a Color Study

Next Freckelton asked her student to make an opaque study of the still life in order to analyze the composition of colors and values. She suggested using gouache, pastel, or acrylic paint, and Ingalls indicated that she would feel most comfortable with pastels.

Because you have come so far in composing in just a few minutes with this little scribble drawing, I think that a color sketch—which would be concerned with just color and tonalities, your darks and lights and their arrangement on the page—would also be of value to you before you begin the painting. Deciding how you are going to use the color and make it work for you will help you organize your thinking and your approach to the painting. In doing this preliminary work, you are learning to look at, think about, and respond to your subject matter in a new (and, I hope, helpful) way. A color sketch should be something that you can rework. By using an opaque medium, you will have more opportunity for complete visual changes on your paper.

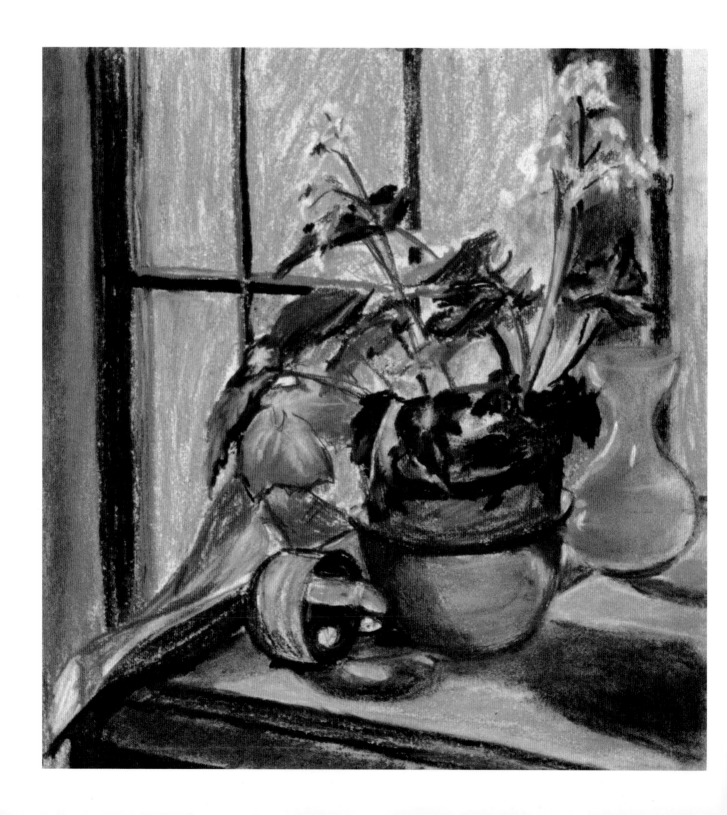

Making a color sketch in pastels helped Ingalls solve
some color problems before beginning to paint.

Ingalls started her pastel color study using the format and placement she had developed in her successful compositional sketch.

SF: *So far, all the color is in the middle of your sketch. Try to think of the color separately, as another element in your painting that you can use to set up rhythms and move your eye around the painting.*

II: *The way I saw it in the beginning, the green in the window glass was a more important color.*

SF: *That might help. If you pull enough color over to one side and have the grays and browns on the other, however, it may turn out that one diagonal half will have color and one half will be neutral. The equal proportions may make it less interesting than it could be. You might want to introduce another object, or you might want to make the cabinet at the bottom a more interesting color. There are many ways to solve the problem. I would like you to think about it and solve it in your own way.*

II: *If the light on the table were yellower, would that help?*

SF: *Try that on your color sketch and see if it begins to work better. You can always change it if it doesn't. That's what a preliminary sketch is for. Work boldly, try out your wildest ideas, change it until you get the color and values working for you.*

Ingalls began working more rapidly, looking at her setup intensely and sketching in the color.

SF: *This is what I really enjoy seeing. You are sitting on the edge of your seat, putting down information quickly and looking very hard at your setup. Your eyes are more often on your subject than they are on your paper. You are on your toes, looking, thinking, jotting down. Instead of drawing each green leaf, you are beginning to draw the relationships of the colors and tonalities regardless of their existence on solid objects or in space. A lot of people have preconceived ideas about what they are looking at. They bend over their paper and draw. They never look up again. You have barely taken your eyes off the subject long enough to put down your marks. That's what I want to see, because then you are transferring information from the setup to the paper. You can always change it if it isn't just right or if you can't use all the infor-*

Ingalls began her painting, keeping her color sketch at hand for reference, with the glass vase. Then she went on to establish some of her darkest and lightest values adjacent to it. These would serve as a key to which she could relate all the other values as she developed her painting.

mation you're putting down now, but the excitement in the way you are working is there, and it's showing on the paper. You are excited about what you are drawing now, and it's coming through.

Beginning the Painting

After Freckelton and Ingalls discussed the direction of the painting as indicated in the pencil sketch and color study, Ingalls drew one grid on a piece of transparent paper (to be laid over her color sketch) and a corresponding grid on the paper she was going to be working on. Because Ingalls would be working in a format squarer than that of the rectangular block of paper, Freckelton suggested that she cover up the lower portion with drafting tape.

Referring to the grids, Ingalls redrew her still life on the watercolor paper with the lightest possible pencil marks.

SF: *After you indicate the placement of your subject on the watercolor paper, lightly redraw your objects from your still life so that they are correct or convincing. Make sure the ellipse and bottom of the vase, for instance, correspond to the angle of the table. The vase must be drawn so that it appears to be sitting on a surface, not floating above it. If you start by painting a background element, the objects in front of it must be well drawn because the edges you leave to accommodate those objects later will be permanently established. Don't let sloppy or lazy drawing spoil your painting— get an object right before you paint it or the surrounding areas.*

II: *I've decided to start painting the green vase. It stands all by itself with nothing in front of it, and I have it drawn in well.*

SF: *You will see a lot of different colors in that green glass vase, so don't allow yourself to think of it as simply green. The vase is both transparent and reflective. All the colors coming through it and reflecting on it, if they are well designed and properly placed, will reinforce the integrity and volume of the vase. Try to keep all your colors bright; don't use any of your grays yet. Keep the painting fresh and lively right now. Richness of color can be lost.*

II: *I have got the vase painted in, but not finished. What do you think I should paint next?*

SF: *I think you are probably going to want to work on that very dark window frame, behind the light pink flowers to set the tone of*

Once the window frame was painted, Ingalls could relate the pale pink flowers to it.

the painting and help you to see how lightly the flowers must be painted against the dark brown. Then you are probably going to want to work on the plant because the plant keeps changing and it is going to lose most of its flowers before you are finished with the painting. Establishing the medium-dark leaves in front of the window will help you key the tonalities of your painting.

Ingalls mixed up enough pigment to cover the area of paper that would become the window frame, applied frisket to mask out the small flowers and stems she had drawn in front of it, and turned her watercolor block upside down in order to grade the wash from light to dark more easily.

SF: *Now that you have laid the brown wash on, don't turn your paper back around. You have graded it darker toward the bottom, and if you turn it back up again you are going to get some "bleed back" and destroy your subtle gradation. Leave it the way it is until it is fairly dry.*

II: *It should dry before I put another color on top of it anyway.*

SF: *Yes, before you make an overlay of a different color, the bottom color should be thoroughly dry. When putting on your wash overlay, make sure you mix up enough color and lay it down very quickly without manipulating your brush a great deal and without using your brush too heavily. You could still move the paint that you've allowed to dry underneath. Unless you paint the overlay lightly and quickly, you will get strange, brushy areas that were not intended.*

SF: *Now that you have painted the window frame in richly, you can see how light you will want to leave the flowers in front. You can start reacting to this first relationship between the objects. Establishing that dark strip has already made the plant in front of it look very active.*

II: *I think I will have to work on the plant for a while because some of the leaves have changed position and the flowers are beginning to fall off.*

SF: *Unfortunately, because you are using a plant that moves and grows toward the light, you have to concentrate on getting it painted before you lose the reference of some of your important leaf shapes and flowers.*

The translucent leaves of the begonia posed certain problems for Ingalls: how could she distinguish between the light coming *through* the leaves—which allowed some of the red undersides to show through as well—and the sheen of the highlights *on* some of their deep green surfaces?

Ingalls continued to work on her painting, concentrating on the plant. She asked Freckelton what her method would be for showing the complicated light coming through the leaves in front of the window.

II: *On this one very dark leaf, there are some places where the bright red of the underside is shining through, and there is another place on the same leaf where it is almost white and picks up the reflected light.*

SF: *Now the reflected white is the white of the paper, but the other light that you want to come through the leaf is red, and yet the leaf is green. One way to proceed would be to underpaint the leaf with red in the places where the light coming through is red, soften the edge of the red underpaint, and stop before you get to the places in the leaf where you will want the white paper coming through reflective parts. Otherwise you would have red showing through those areas as well. Put your red down richly and feather your edges so that you don't get hard lines under your green paint. After the red has dried, paint on your green, being careful not to cover the places where you will want pure white and pure red. While the green is wet, lift off paint where you want soft edges or subtle shades of red or white.*

Keep your reds and oranges in the underpainting of the leaf very bright. You have got a lot of those red leaves coming across a red cloth, and that red cloth pales next to the light coming through the leaves. The cloth is a dead thing—it should be bright but not as brilliant as the living plant.

When you are painting these flowers, especially the ones that are very light and very fresh in front of something very dark, you don't want to get too involved in each detail in them. If you put too much paint on the flowers, you risk losing the impression of lightness, or airiness. If you play with them too much, you will lose that contrast and the immediate impact that they can have. There are some other flowers here that are in front of a window—they appear darker and you can see more detail in them. Paint those first—get an idea of how to paint them—and once you have painted the darker flowers, you will have a better idea of how to treat the very light flowers with less paint and make them as convincing as the fully detailed ones in front of the window. If the flowers in front of

Freckelton's suggestion for painting the problematic leaves worked well for Ingalls: she underpainted only the translucent areas with a transparent wash of red and then carefully lifted out portions of the green overlay for both the highlights and back lit portions.

the window are quite pink, the others will appear pink with a few indications of color, and you will still have the light appearance of those flowers popping out in front of the darker wood.

You must not lose sight of the intent of the whole picture. You constantly have to think in terms of the whole impression of the painting and how each part you work on contributes to that end. Because you are a little unsure, you are getting a little too involved in the flower details and forgetting about their effect on the whole painting.

It would be safer to work out the details of the flowers on the ones that are a little darker and can stand a little more paint manipulation than on the ones that must be kept very fresh.

Ingalls worked next on the pot containing the plant, laying in the shadow and reflections, and overlaying the body color of the objects, grading it from medium to light to dark orange.

☙ Developing the Painting

Freckelton continued to stress a logical development of the painting as Ingalls moved from one shape to another. She advised her not to go too far with any particular object until the entire surface was covered with paint and she could relate each area to all the others.

SF: *You still have the tabletop to paint in. Let's get rid of that pure white paper. It is misleading your reading of relationships and makes it difficult to see what the rest of the painting requires.*

II: *Should I put in the yellow of the tabletop first, or should I get the shadows in?*

SF: *The value and shape of the shadows is very important because they control a large portion of the paper. It may be better to do the shadows first. It will be easier to manipulate and change those shapes without fear of dirtying the yellow.*

In some of these very dark, vague areas (back leaves and rhizomes, where the plant goes into the container) you might lay in a dark tone within your outline and then pick out some of the lighter forms with your brush to delineate the form within the shape. This method will ensure your getting the area dark enough without a lot of edges. You can treat the area in a more generalized manner and contrast it with the very specific leaves in the front.

Ingalls painted more begonia leaves, this time with
more confidence, and then began to establish the
stem and blossoms at the upper left.

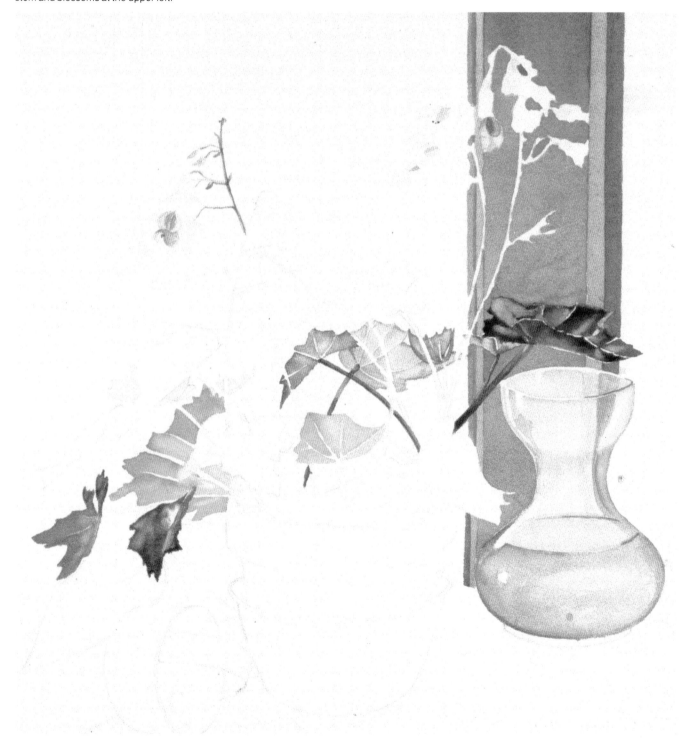

When you are designing the folds in the cloth with your paint, try to think of it as a three-dimensional object. Even though you are painting on a flat piece of paper, think of your brush as going up and over a fold, and try to imagine what is happening to that fold when it disappears from your sight. This attitude will help your drawing to have more volume. You will be describing that form with your brush.

When you are working on your cloth, where it is all very soft within the interior of the reds, you might try wetting the whole area and working into the wet paint. Try shading the red with a blue color, tipping it into the wet red where the shadows fall. Let the shadow color mix on the page. Once you get it to a satisfactory stage, let it dry and do your finishing once you can see the way the paint settles down. If you work too long in the wet paint you end up taking away as much paint as you are attempting to apply. If you begin to lose control of the wet-in-wet paint, let it "dry back" a little before you continue working in the area. If you remove too much of the red when trying to work on the cloth, don't worry about it—let it dry back, and then overlay more red.

Completing the Painting

Ingalls finished the painting in the last of several sessions in Freckelton's studio. She made small adjustments to integrate the painting and resolved passages she was not sure of until she had brought the painting further along. She brightened the color of the rim and bottom of the vase and darkened the shadow under the cloth. She decided to give more color to the chest on which the still life rested, in order to give a greater sense of volume to the bottom corner.

Ingalls was very pleased with her finished painting. Her general reaction was that the workshop with Freckelton had given her a real understanding of watercolor and a systematic approach to the development of a painting that took advantage of the medium's natural characteristics. She was looking forward to applying some of the combinations of techniques she had used on this painting to her next one, and perhaps even inventing some of her own. Ingalls felt that she had learned to give more thought to composition and drawing, which would help her with her paintings in the future. She also felt less tentative about working with a

Ingalls painted the red cloth, top, wet-in-wet to convey the softness of the fabric. In contrast, she painted the vase with crisp definition.

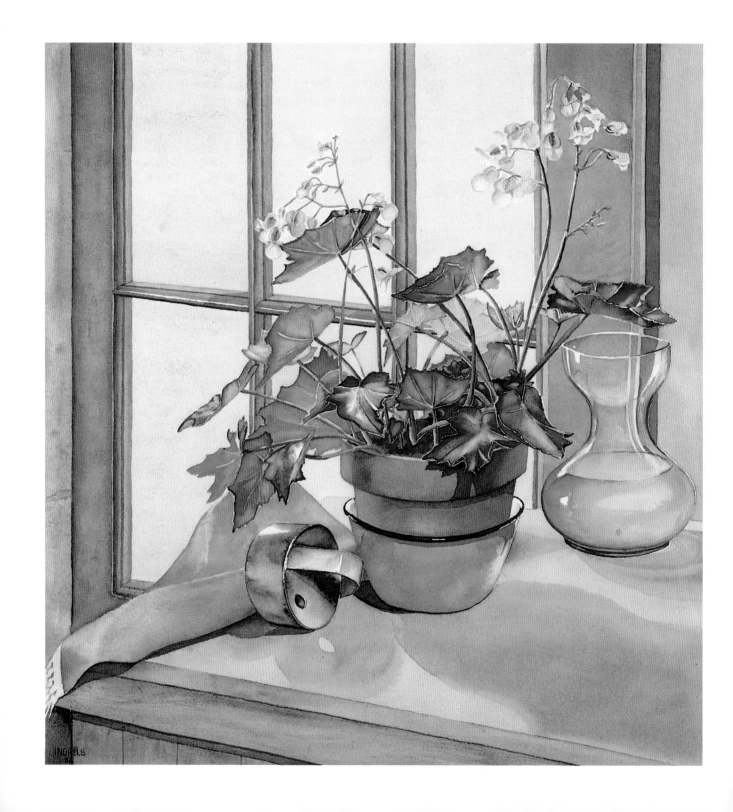

Ingalls' finished workshop painting demonstrates far greater control of her medium than her pre-workshop painting shown on page 71. The objects here have been observed and drawn much more accurately; there is greater tonal variety and more subtlety in the rendering of objects; and both transparent layers of color and the white of the paper have been used much more effectively.

Ingalls painted the tangle of begonia stems and leaves very convincingly, rendering the leaves in front more specifically than those inside the pot, which were in shadow.

full saturation of color. The paper she had been accustomed to using previously was not as responsive to her painting style as the paper she had used during the workshop. She determined to buy some papers with more tooth and to find the one that was best suited to her painting methods. She found that working on a good, easily adjusted work table, with her materials easily accessible, helped to maintain a continuity of thought and response while working, and she looked forward to making some changes in her work habits.

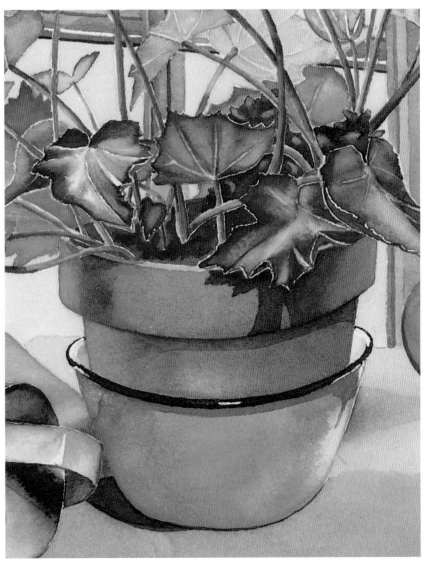

WATERCOLOR FOR THE EXPERIENCED OIL PAINTER

Dean Hartung setting up his still life in Freckelton's studio.

On several occasions Freckelton has been approached by artists whose "serious" work has been done almost exclusively in oil or acrylic paints. Recognizing that there are many differences between transparent and opaque media, they ask questions about the materials, procedures, and the unique technical aspects of watercolor. Freckelton welcomes such inquiries because she feels that in the second half of this century, the watercolor medium has been sorely neglected by professional artists, and she looks forward to a greater expansion and exploration of the medium within the body of work produced by American artists.

As a way of presenting this advice to oil and acrylic painters—and at the same time, restating what watercolorists need to know—Freckelton set up a workshop with the accomplished young oil painter Dean Hartung. He traveled to Freckelton's farm in early June, when the flower gardens were overflowing with poppies, peonies, irises, wild flowers, and dozens of other colorful blossoms.

The workshop with Hartung began with a general discussion of the differences between the opaque and transparent media.

There is a conceptual difference between working in watercolor on paper and working in oil paint on canvas. Watercolor is more like sculpture than it is like painting. The paper, unlike canvas, is not a surface you are working on. It is a surface that will become part of the whole. You will be taking away the white of the paper with your translucent paints, while leaving pure white paper in chosen areas. You will have to keep the whole page in mind, just as you would a piece of stone or wood while removing or working smaller parts of the piece. Achieving the brilliance of strong color in watercolor depends on your use of the paper, on how well you suspend your pigment so that your paper shines through the color you are applying.

ᏋMaterials

Hartung had come to the workshop without any painting supplies, as he had not done any watercolor painting in recent years and didn't have any paints, brushes, or papers that were particular favorites. Freckelton gave him some of her own tools and supplies to use so that he could begin to determine which ones would be best suited to his needs.

First Freckelton and Hartung discussed what paper would be most suitable to his needs:

SF: Unless you know that you want to paint in a very detailed manner, for which a smooth paper would be indicated, or in a very broad way, for which a rough paper would be the most advantageous, I would recommend a medium-grained paper on which you can get both sharp detail and good broad washes.

DH: *The more tooth the paper has, the broader the wash you can get?*

SF: Yes, you can get a wash that appears cleaner and more brilliant on rougher paper.

DH: *So the brilliance occurs how, then? It doesn't occur in a flat wash?*

SF: It does, but the more bumps and tooth the paper has, the more pigment it takes in each one of those hollows. The hollows of the paper hold the pigment in place, giving the appearance of a smoother wash. Have you ever used a really smooth bond paper and tried to do a wash drawing? The paper is almost repellent. The paint does not stay where you put it down. It puddles up in the large wash areas.

DH: *Like stained glass. Where the glass is thin, the color is light; and where it's thick, the color is darker.*

SF: Yes, the way areas of heavy color combine with the more lightly tinted places in a section of stained-glass window is very much like what is occurring in a microscopic view of the paint on the hills and valleys of the toothed paper. There are differences, too, in the way paper is sized that will affect your painting. If the paper does not have a sufficient coating of external sizing, the paint will sink into it and lose some of its brilliance. An extreme example would be the difference between painting on a paper napkin and painting on a sheet of coated bond paper. Even with a well-sized paper, the paint will appear somewhat lighter after it is thoroughly dry than it did when it was applied. I usually paint areas more brightly than I really want them to be so that when they dry they will have the intensity I was after at the outset.

DH: *Does that apply to the values at all? Do the values change?*

The leaf in this detail from Freckelton's painting *Sunflower* (page 136) shows how the bumps and hollows of the paper hold the pigment when a wash is applied. A smoother paper might have allowed puddles to form, destroying the evenness of the wash.

SF: *Most often they dry lighter also. If you really want to get your value right the first time and you are unfamiliar with the color you are using, it pays to test the color first on a scrap piece of your paper. Let it dry while you are working on something else. If the value is not right when it is dry, you can adjust the mixture in your pan and avoid laborious and sometimes disastrous attempts to make corrections on your paper.*

Most experienced oil and acrylic painters have a certain palette of colors they use which reflects their style and the subject matter that interests them. When changing to watercolor, these artists have to reexamine their selection of colors because of the differences in the way pigments work in the watercolor medium.

I strongly recommend that artists moving to watercolor make color charts because the charts help explain how different paints respond. As you graduate the various colors across the page from pure pigment to pure water, you will begin to see how some colors remain grainy while others flow out smoothly and how some apparently "clean" colors dirty up with the addition of water. The appearance of the gradation from raw color to a tint is often very different from what you might have anticipated. You will notice that many of the browns are difficult to grade out smoothly. One remedy for this, if a large, smooth area of brown is desired, is to mix up a large quantity of dark brown, let it sit in a cup or jar for a while until the particles settle, and then decant the liquid from the top. This way the particles of pigment that simply won't suspend can separate from the usable paint, settle to the bottom of the jar, and be discarded.

You can glean further information from your color charts that will be helpful. As an example: Ivory black is more grainy than lampblack; therefore, lampblack is a better choice for covering large areas. Hooker's green will stain the paper more quickly and permanently than sap green, which does not dye the paper and therefore is more easily manipulated and can be lifted off the paper more cleanly.

Someone who is used to working with oil paints would also have to get into the habit of mixing larger quantities of the colors he or she intended to use. Hartung was given small divided dishes for laying out his palette as well as some larger individual mixing dishes.

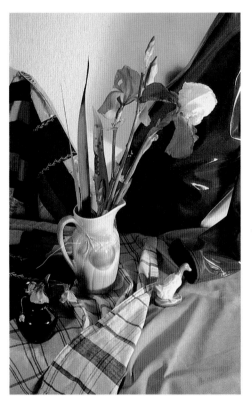

Hartung's arrangement included textiles with contrasting patterns and both mat and shiny surfaces; manufactured objects; large, showy irises and delicate pansies from the garden; and an interesting interplay of light and shadow.

❧ Painting Exercises

Freckelton had her advanced student undertake exercises in laying a broad, uniform wash on a piece of scrap watercolor paper and lifting portions with a sponge. She also had him paint hard- and soft-edged shapes so that he would understand how wetting the paper would help him avoid the stiff, hard edges that result from painting on a dry surface. He also painted some random patterns with several tube colors and then glazed over these when they were dry just to see how the layers of transparent paints gave interesting color blends he was not used to getting with oil paints.

The method of applying paint in watercolor is quite different from that of oil. Instead of the daub-and-spread method suited to thick, opaque paint, try to suspend your pigment well in water and simply guide the flow of your color.

By far the biggest difference between the ways you handle the individual media is in the way you organize your approach. You have to be more systematic and orderly in your approach to watercolor. Where an oil painter might begin with a loosely painted thin sketch of the subject on his canvas, a watercolorist cannot make such preliminary marks and hope to correct or conceal them with subsequent layers of paint. Every stroke of paint alters the surface in some permanent way, thus requiring the artist to consider each one carefully. Watercolor can be as bold and expressive as you desire, but you must think and plan your approach before you put your brush to the paper. What you do on the paper is very quick, very immediate, and the paint will be dry in minutes. Your chance to change or manipulate it will be diminished or gone by the time the paint dries.

❧ Choosing the Subject

Once Hartung felt confident about handling the new medium, he set about selecting his subject matter for the painting. Being an experienced painter, he had definite ideas about what he wanted and did not want to paint, and he looked around Freckelton's house searching for objects to include in his watercolor. He began to assemble these objects on a table in the second-floor studio, adding elements and taking them away until he was satisfied with the composition. Freckelton told him he would have no trouble making a painting of varied and wildly patterned materials, and

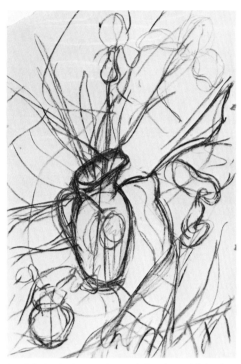

A quick, freely drawn charcoal sketch established the center of interest, the general placement of objects, and the major directional movements in Hartung's composition.

in fact might find it easier to record shapes and surfaces that were broken into complicated patterns than those that were uniformly solid.

Hartung finally arrived at a composition of objects and fabrics, but he decided he would like to incorporate some irises and pansies from the garden. Freckelton suggested that he wait till he was satisfied with all the other elements in the setup before he cut the flowers so they wouldn't have to sit under the spotlights for a long time before he started drawing and painting. When the time came, Hartung cut some of the flowers, set them in the vases, and started in on the drawing.

Making a Charcoal Sketch

Hartung usually starts preparing for his oil paintings by making bold charcoal drawings of his subject until he arrives at a satisfactory composition, and Freckelton suggested he proceed in the same way with this painting. Once his free and loosely drawn study was made, however, Hartung would have to redraw the setup lightly in pencil on the watercolor paper. Charcoal would simply be too strong to use on watercolor paper.

Hartung's charcoal sketch established the proportions of his painting, and next he cut a piece of Freckelton's 140 lb Arches paper from the roll in her studio. This was taped down to the board on top of one of her drawing tables and secured with push-pins around the edges. Strips of tape were then used to block off part of the bottom, as the cut paper was not exactly the right proportions. Once these preparations were completed, Hartung redrew his still life subject in pencil, referring to his charcoal sketch and the objects in front of him.

Because Hartung was an experienced painter, Freckelton did not feel it was necessary for him to prepare an opaque color study. She knew he could handle the compositional problems of balancing colors and values, and he was used to painting with a "whole picture" awareness.

Beginning the Painting

Next Freckelton engaged her student in a discussion of how the painting would progress. First they agreed that since the irises dominated the painting and would be changing their appearance

Before beginning to paint, Hartung masked off the proportions of his watercolor paper, positioned his easel and light source carefully, and lightly indicated his composition in pencil.

in a matter of hours, they were the objects to be developed immediately.

DH: *Should I start with the white petals on top of the purple petals? Should I lay down a pretty strong wash of purple and then work into it?*

SF: *You have to do the white petals and the purple petals separately so that they keep their own crisp definition. It would be a good idea to use a strong purple and then lift off paint to get a soft tonality within the petals. You'll have to decide on the shadow color for the white petals. If you use black they will probably have a dirty appearance; instead, try to use something that is more of a color for shading the white.*

DH: *I thought I could use the gray that seems slightly purple, the neutral tint. The white is probably going to be the white paper.*

SF: *Yes, leave more pure white paper than you think you are going to need. You can adjust the amount of white later along in the painting. Push the purples, paint them a bit stronger than you think you will want because the color is not going to be as dark as it appears when it is wet, and deeper color will give you a better contrast when you lift out paint to expose lighter areas. Since you are starting first with the flowers, you can key the painting to them. Keep it bright at first.*

With that plan established, Hartung selected Winsor & Newton's violet and neutral tint as the basic colors for the bitone irises and began painting into one of the flower shapes. He labored over this flower for almost an hour until Freckelton advised him that he should move on to the other flowers before getting down to the fine details of one shape. The next flowers were painted more quickly, as Hartung was gaining confidence and feeling more comfortable with the medium. By the end of the day's session, all of the irises were painted in well enough that he could move on to another area of the paper without worrying about the changes that would take place in the flowers.

🍃 Developing the Painting

The logical area to need attention next was the dark slicker hanging behind the irises because it was adjacent to the irises and was the darkest mass within the composition.

Hartung developed the dominant irises first and then began work on the dark slicker adjacent to them. He followed Freckelton's suggestion that he start with the shadow areas first, working only in grays to define the form.

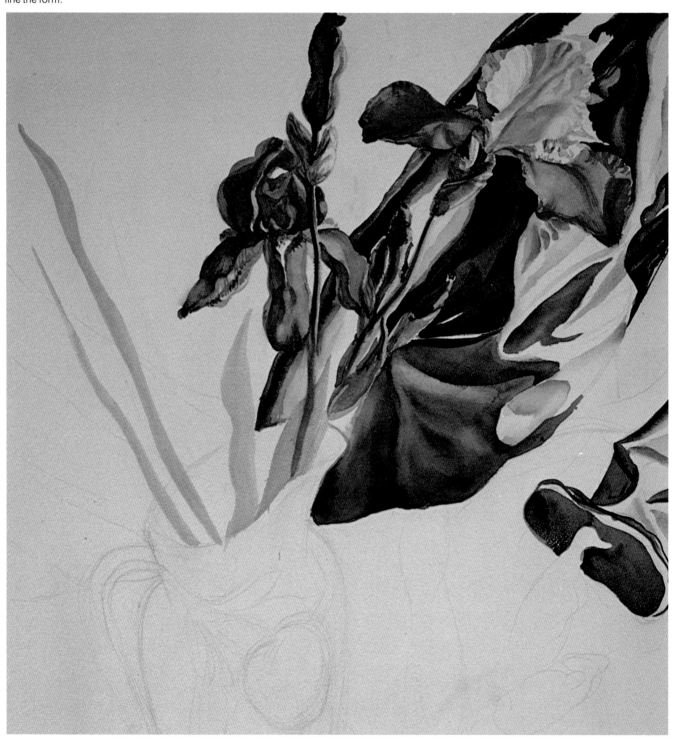

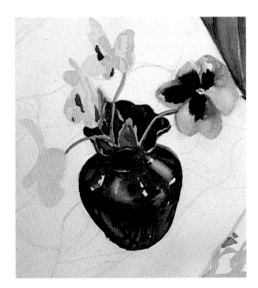

After drawing more of his still life setup, Hartung painted the small vase of flowers, top, and began the underpainting of the tablecloth, above.

When the workshop resumed the next day, and Hartung was preparing to paint the dark red slicker, Freckelton pointed to two of her own paintings tacked to the wall.

When I have shadows cutting across large areas in a painting, I often paint those shadows first and then overpaint the general color of the object. The result is cleaner because no paint is disturbed in the body of the object when the shadow edges are softened. I would recommend that you paint in the shadows of the slicker first, not only to get good-looking shading but also to provide yourself with an underpainting guide for quickly manipulating the rich color of the slicker. When you start overlaying the browny-reds of the slicker you will be working wet-into-wet, using your underpainting as a map to your form. You will have a better understanding of the folds and flow of the cloth and will be aware of where your whites will be left. If you paint the slicker in two stages, you won't overwork it too much. You will solve some problems in the first stage and others in the second without spending too much time in the wet paint and ending up with a scrubbed look. Make your underpainting a little bit less dark using a neutral brown or sepia so that it will lay under your final layer of paint and act as a guide to quick, sure strokes of bright color. If you paint your brilliant colors down too slowly, trying to work back into areas that are beginning to dry, you may end up taking off more paint than you are applying. You want to paint it all at once, while all the paint in the area is equally wet, adding paint and lifting it off quickly and with a sure hand.

Hartung made an underpainting for the slicker, carefully designing the dark areas behind the thrust of the light iris. While waiting for this to dry, he drew in some of the other still life objects. Next he worked in his rich red colors on the slicker quickly and then moved confidently to the small dark blue vase in the opposite corner and the underpainting of the tablecloths. He was in doubt about the color of the striped tablecloth under the vases, and so he decided to tackle the boldly striped quilt in the background in order to have more information down on his paper before making that decision.

SF: *The color of the tablecloth under your objects is so close to the color of the pitcher that you may want to make more of a color change than a value change. You can make that judgment better*

94

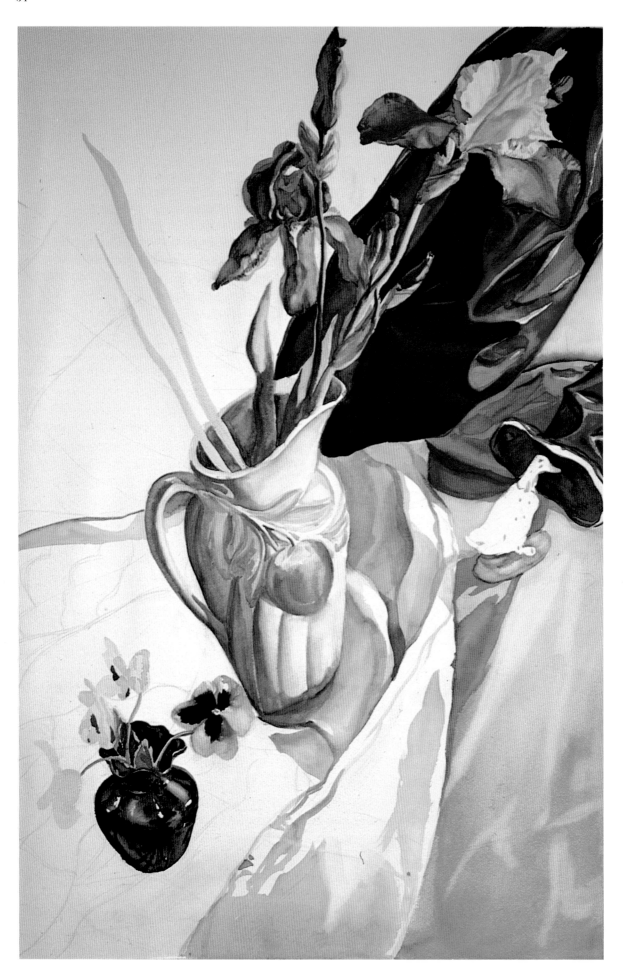

Next Hartung overpainted his tonal ''map'' of the slicker with red, leaving small areas of white paper showing for the brilliant highlights. As he began developing the rest of the painting, he related the colors and values of the other important objects to the slicker and irises. He masked the embroidered lines on the quilt, below, before painting the dark stripe. He took special care in establishing the directions of the stripes on the plaid tablecloth, bottom.

once you put in the broad, dark stripes of the background cloth.

DH: *Should I mask out the little thread lines in the embroidered cloth?*

SF: *It would be much easier, yes, to paint that on with frisket so that you can paint the entire piece of cloth in one smooth flow without having to go around all those little chicken scratches. It will be interesting to introduce just that little bit of yellow embroidery in the dark stripe.*

After the quilt was completed, Freckelton and Hartung discussed the color of the striped tablecloth. Hartung decided on a base color of light sepia to keep the color in the brown range, without leaning toward either red or the yellow-brown of the pitcher.

SF: *The stripes that go across the very subtly colored cloth, even though they are not dark or obvious, establish the tabletop on which your objects are sitting. I would recommend that you take off some of the sketchy lines and redraw the stripes to establish the tabletop, the folds in the cloth, and the plane going back. You don't have to proceed in this way when you are working in oil because you can draw and correct while you are painting. But when you are working with transparencies, you can't redraw so much with your brush. I like the kind of looseness and freedom that you are working with. I don't want to spoil that, but I think the cloth still could be painted loosely and freely and look more positive if you knew where your folds and stripes were going to be and were assured that they were establishing the surface on which your objects are resting.*

Completing the Painting

After the tablecloths were painted, the only major decision still to be made was the color and manner of treatment of the wall behind the still life. Hartung decided that the whole wall should be toned slightly so that the whites he had left in the foreground objects would be intensified.

SF: *What do you think about that shadow on the wall? Do you think it should be kind of warm, or should it be cool?*

DH: *I think it should go toward the blue.*

SF: *You don't think it is going to tie the iris down too much?*

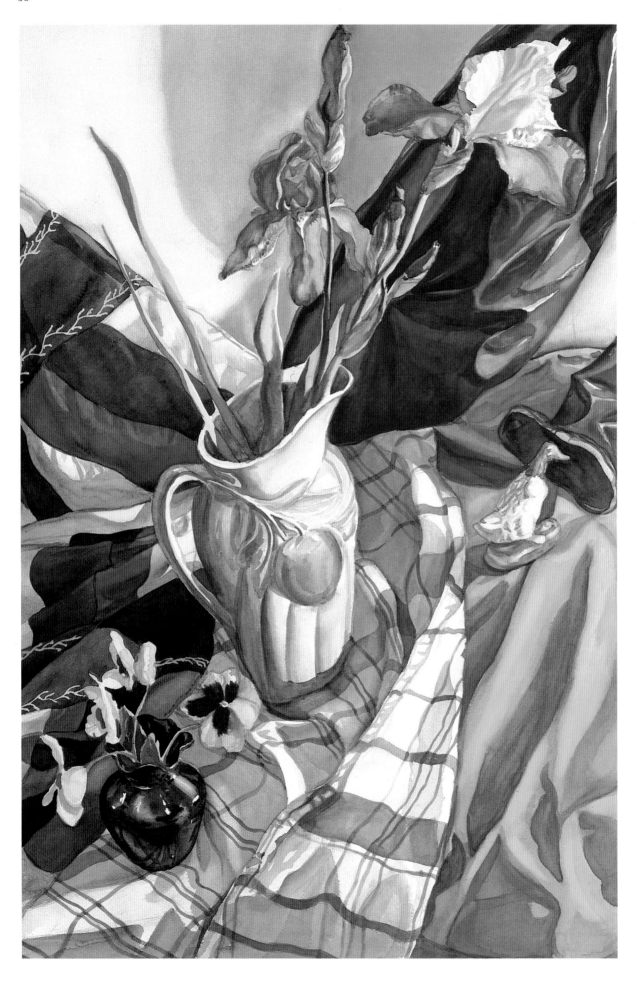

Despite its variety of textures, patterns, and objects, Dean Hartung's finished painting is unified by an overall color mood. The movement of fabrics and shadows gives the composition strength and vitality; and he has painted the cast shadows as solidly as the objects.

DH: Oh, that's right, maybe it would.

SF: The shadow does look blue when you look at the still life, but for the painting maybe it should be a little warmer. It could be very neutral. You could do with a grayed tone of lampblack, or you could keep it cool, on the green side, and use something like Davy's gray.

DH: Yes, that would be good.

SF: Davy's gray doesn't mix up very dark. But it would be closer to what you want. It would be different from the cloth and the iris.

DH: The only problem I had with the Davy's gray was that it wouldn't lay right when I used it for the shadow inside the pitcher.

SF: Davy's gray goes a little opaque when you mix a lot of pigment with a little water, and it won't lay on smoothly in those proportions. You might want to mix in a little lampblack or a bit of some darker pigment in order to get a deeper tone and still keep the paint transparent and not so thick. I guess you want that wall shadow pretty smooth as a contrast to the painterliness in the cloth and objects. You can sponge that whole area before you paint the shadow.

DH: When I put on the water, should I just cut in around the edges here so I don't get any bleeding into the flowers?

SF: You haven't done much erasing or disturbing the nap of the paper near the flowers, so don't wet your paper right up to them. You should turn your paper so the flow of the paint will be running away from the flowers and your more complicated edges. Then you can start your wash by painting around the complex forms carefully; you can move more quickly as you get out to more open spaces.

After the shadow wash was applied and dried, the rest of the background wall was toned with a lighter wash of Davy's gray. A few finishing touches later, Hartung had completed a very successful watercolor. He was pleased with his introduction to watercolor. He thought one of the most important things the workshop experience had made him aware of was the planning that went into the most direct, fresh-looking passages of his painting, and he was anxious to investigate the medium further.

Part Four

Gallery

The preceding sections of this book have focused on process—on
the method and "sense," so to speak, behind Sondra Freckelton's
work. Now it is time to experience the other important aspect of
her paintings—their impressive visual beauty and the sensibilities
they express. The finished paintings in this gallery are presented
in a loose chronological order, with captions that are only meant
to provide basic information about the paintings and link them to
previous discussions of the artist's working methods. Each viewer
will find a personal enjoyment in these illustrations which goes far
beyond what might be suggested in words.

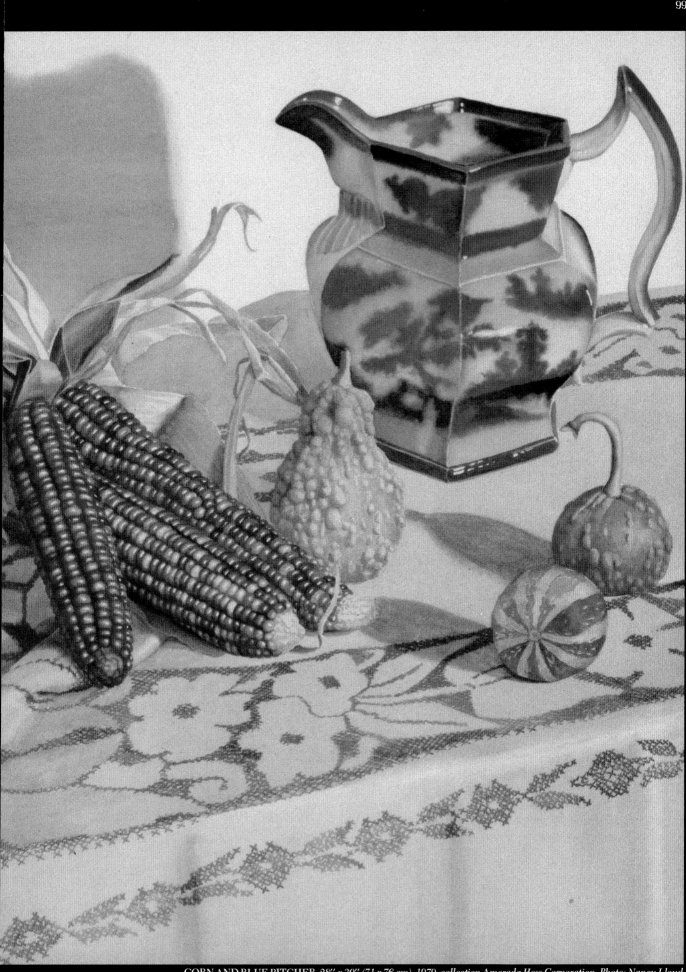

CORN AND BLUE PITCHER, 28" x 30" (71 x 76 cm), 1979, collection Amerada Hess Corporation. Photo: Nancy Lloyd.

As Freckelton pointed out in her workshop with
Irene Ingalls, cast shadows can be used in a composi-
tion with as much weight and importance as a solid
object. In this painting, the shadows were used to es-
tablish a sense of space and volume and to counter-
act the dominance of the blue colander by repeating
its theme throughout the painting. Even the kernels
of the stripped ear of corn in the upper right-hand
corner, where the shadows cannot reach, are a re-
verse repetition of the colander holes.

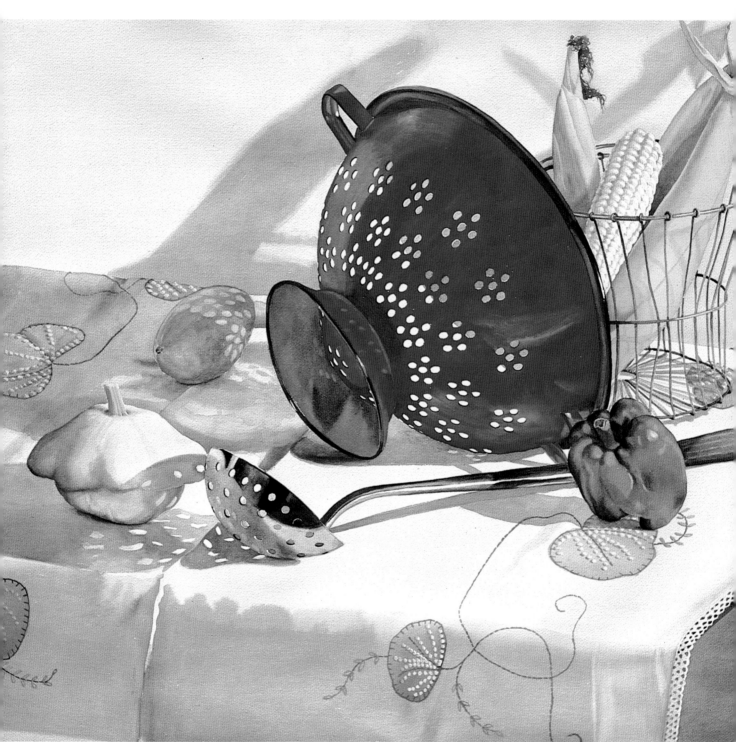

BLUE COLANDER, 29″ x 31½″ (74 x 80 cm), 1977, private collection, courtesy Brooke Alexander, Inc., New York. Photo: Eric Pollitzer

A subtle, soft underpainting of grayed tones was laid down to indicate the folds and draping of the whole cloth. That unified the whole painting and provided a guide for Freckelton as she painted the quilt with attention to the puckering and placement of each individual patch. The underpainting of the red parts of the quilt was almost entirely obliterated, but due to that underpainting, Freckelton could quickly apply tones of darker reds and browns by tipping them into the wet, bright red stipes and patches without losing the continuity of the whole quilt.

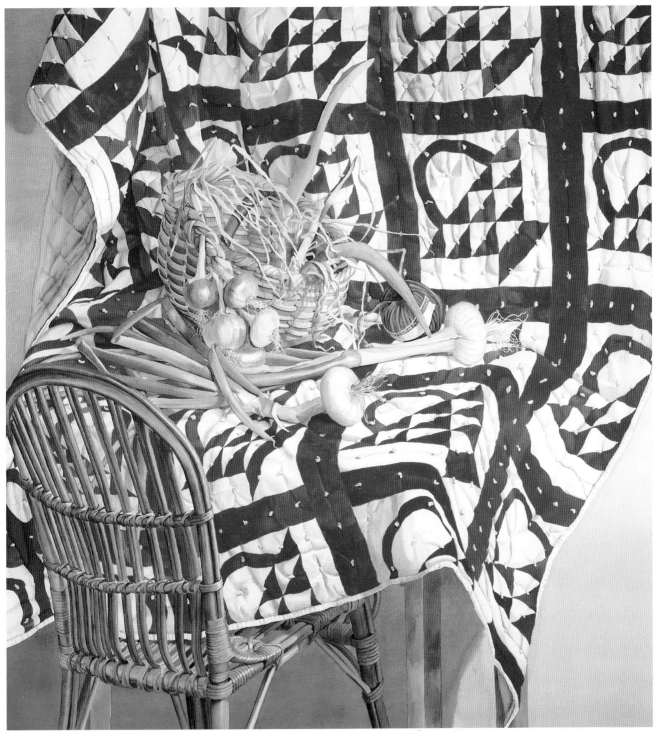

ONIONS AND BASKET QUILT, *47″ x 43¾″ (119 x 111 cm), 1977, Springfield Art Museum Collection, Missouri, purchased with the aid of funds from the National Endowment for the Arts*

102

Occasionally Freckelton does watercolors that in-
corporate live "models" like this duck. In such situ-
ations, her preparatory drawings and paintings help
her solve the problems of dealing with a subject that
will not "pose."

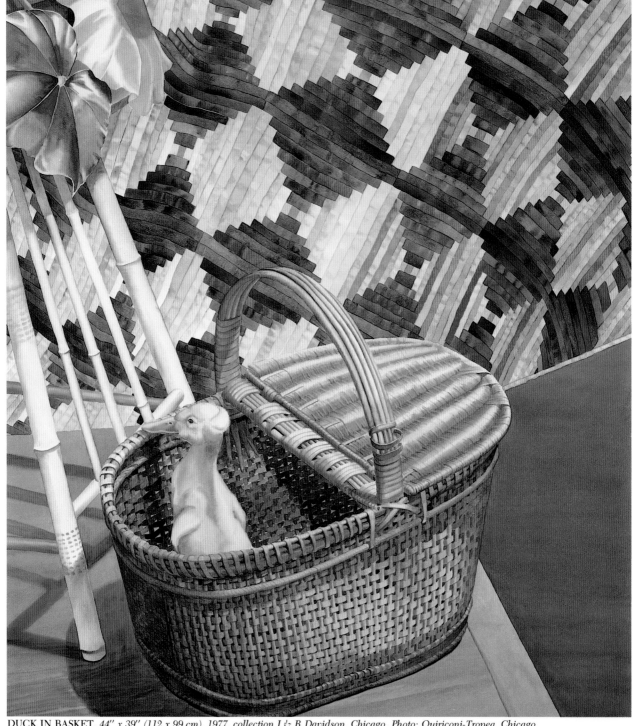

DUCK IN BASKET, *44″ x 39″ (112 x 99 cm), 1977, collection J & R Davidson, Chicago. Photo: Quiriconi-Tropea, Chicago*

The bright highlights on the leaves and fabric create a convincing representation of the begonia plant and satin cloth. Many of these areas were established by painting the shape with a solid color and lifting off paint to create highlights. Once dry, some of them were developed further by modeling the form with darker values.

The duck was painted with wet-in-wet techniques to keep its appearance soft and fragile, while the basket enclosing it was painted on dry paper to indicate its contrasting hardness and to keep the intricate weaving well defined.

This painting is based on the garden in front of
Freckelton's Oneonta, New York, farmhouse; it
presented compositional challenges similar to those
explored in the painting demonstration in Part Two.

SPRING GARDEN, *38″ x 46¼″ (97 x 117 cm), 1978, private collection. Photo: Nancy Lloyd*

One of the most intimate paintings in this book, this watercolor presents delicate peony blossoms set against a grayed patchwork quilt.

PEONIES, *23″ x 22″ (58 x 56 cm), 1978, private collection, courtesy Brooke Alexander, Inc., New York. Photo: Eric Pollitzer*

HARVEST, *44″ x 58″ (112 x 147 cm), 1978, collection the Roby Foundation, New York. Photo: J. D. Schwalm, Owensboro, Kentucky*

The scale and complexity of this painting challenge the notion that watercolors must be sketchy, small, and quickly executed. Freckelton has developed a monumental composition without denying the natural characteristics of the paint.

Freckelton emphasizes that she wants the objects in her still lifes to seem "more round, more full, more lively" than they appear when they are sitting in front of her. That is true of the objects here—the precariously tilted colander and the cherry tomatoes that have rolled from it and are not quite at rest on the starched, unrelaxed tablecloth. They derive their vitality from the artist's presentation.

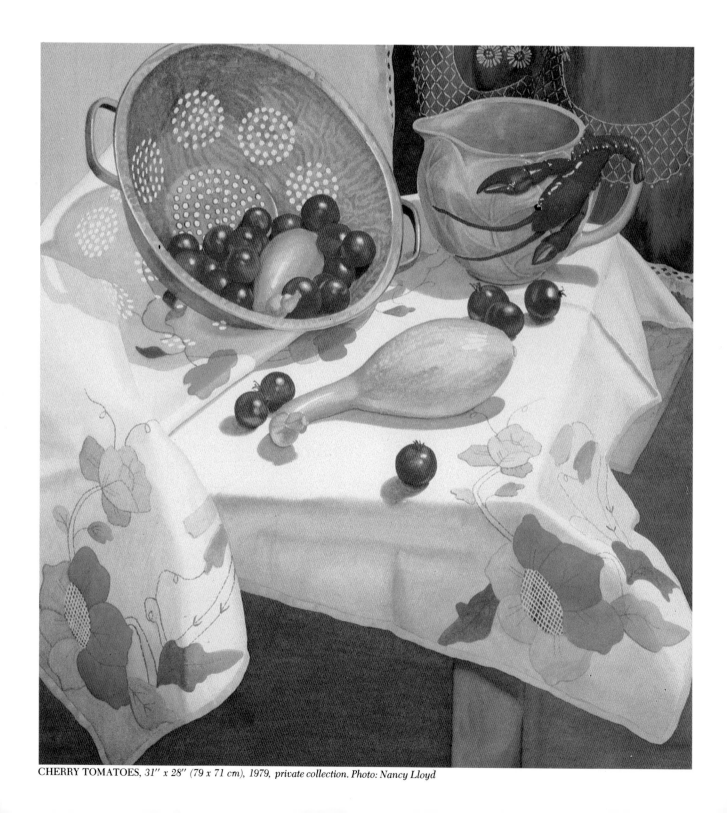

CHERRY TOMATOES, *31" x 28" (79 x 71 cm), 1979, private collection. Photo: Nancy Lloyd*

One of Freckelton's best-known paintings, this work has been exhibited with the Davidson Collection in Philadelphia and Chicago, was reproduced in the catalog for that show, and is included in the book *Realist Drawings and Watercolors* by John Arthur (New York Graphic Society, 1981). The bulging head of cabbage, placed at the vertex of the wheelbarrow's edges, is the focal point of the composition. The arcs formed by the sides of the wheelbarrow, the wicker basket, and the sunflower seem to radiate from the cabbage.

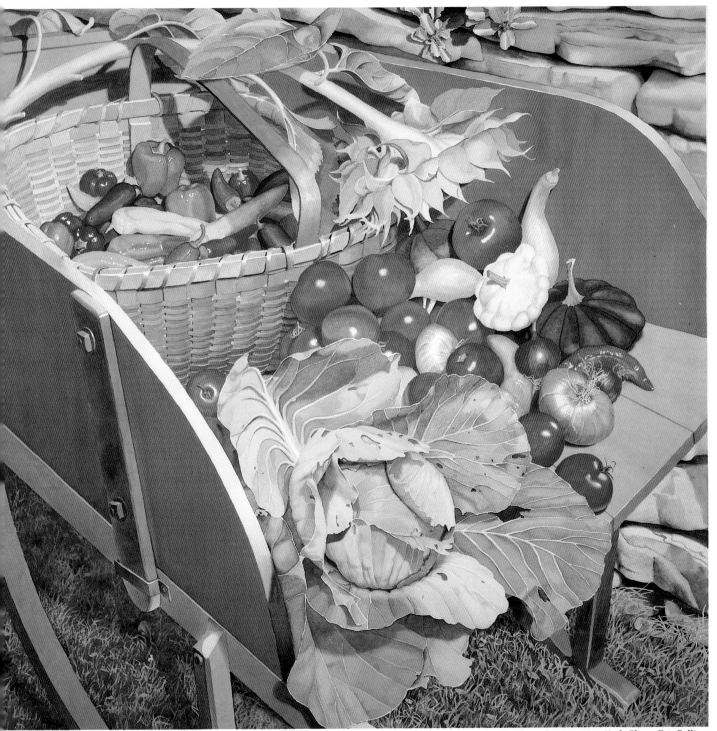

WHEELBARROW HARVEST, 41½″ x 41″ (105 x 104 cm), 1979, collection J & R Davidson, Chicago, courtesy Brooke Alexander, Inc., New York. Photo: Eric Pollitzer

110

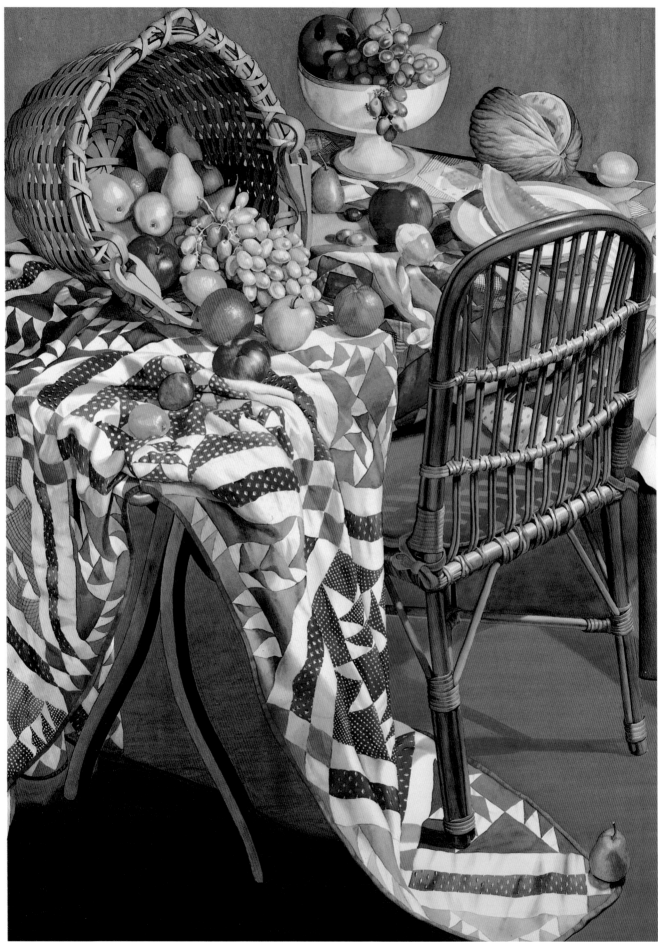

STILL LIFE, 60″ x 44¼″ (152 x 112 cm), 1979, Owens-Corning Collection, Owens-Corning Fiberglass Corporation, Toledo, Ohio

This painting was included in a major exhibition at the Allan Frumkin Gallery in 1979 entitled "The Big Still Life." In the tradition of American still lifes, it is full of rich details that celebrate nature's bounty. Every part of the painting speaks of abundance.

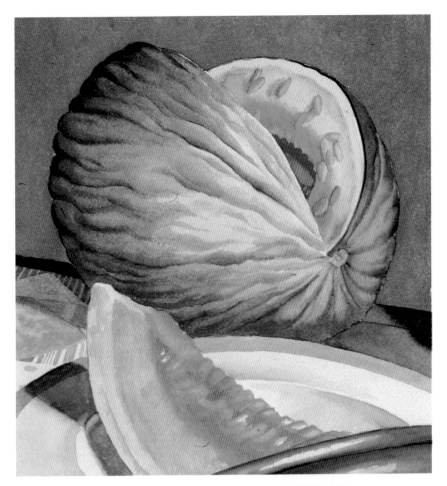

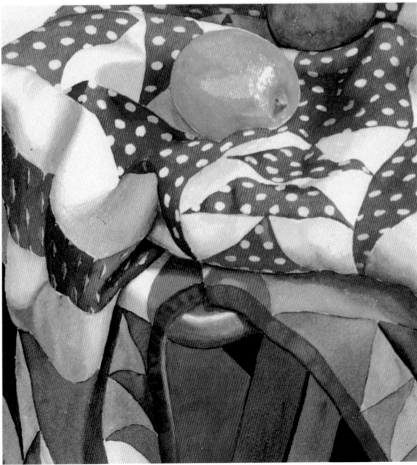

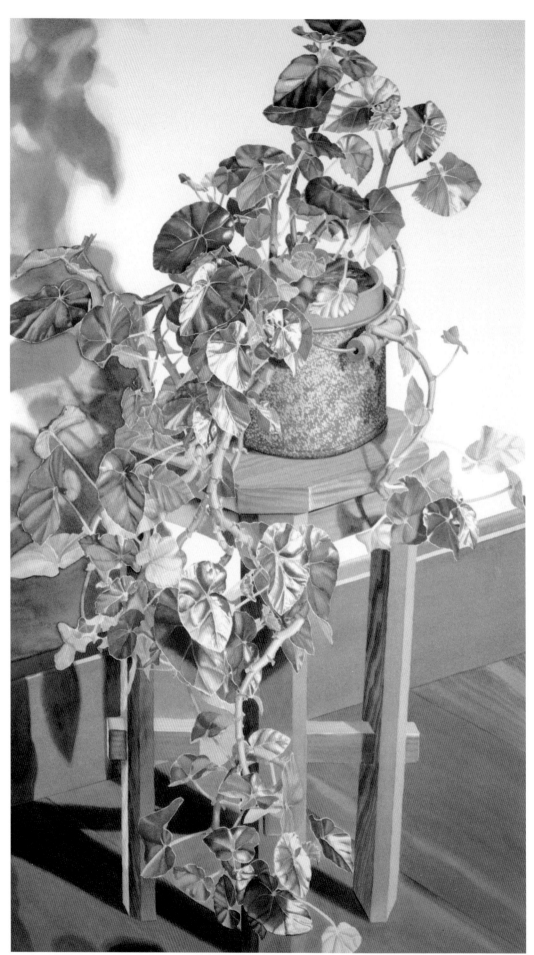

TRAILING BEGONIA, 28½″ x 46″ (72 x 117 cm), 1979, private collection. Photo: Nancy Lloyd

(Opposite page)
Sometimes compositions made up of one or two elements are the most difficult to turn into interesting paintings, and Freckelton usually advises her students to start with still life arrangements that involve several objects and patterns. Once they are in control of the medium, it is easier for them to paint compositions of just a few objects, as Freckelton has done so successfully here. By exaggerating important spatial thrusts, making full use of the plant's shadows, and throwing the wall and floor at an imposing diagonal, she has created a full and exciting composition from a single object on a table.

(Below)
The stylized leaves in a piece of lace material combined with a living plant present an intriguing juxtaposition for a painter. In this painting, the contrast between the openwork of the soft lace cloth and that of the rigidly defined wicker furniture also interested Freckelton. The cloth was borrowed from someone who uses it mostly for special occasions such as weddings. The love and respect that have gone into its making and use enabled Freckelton to put the same kind of dedication and long hours into her rendering of the lace.

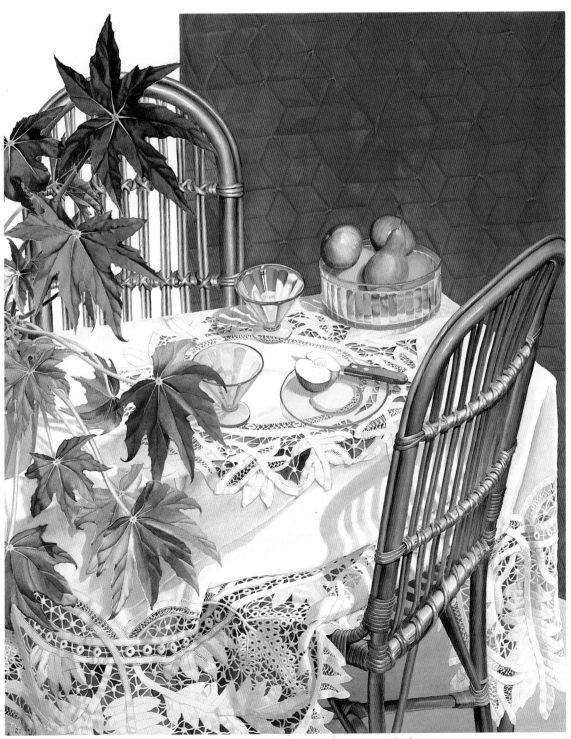

FRUIT AND LACE, 48½″ x 41″ (123 x 104 cm), 1979, private collection. Photo: Nancy Lloyd

114

Because the cut flowers remained fresh for such a short time, Freckelton had to paint each one separately and then develop the quilt around them. Her preparatory sketches make it possible to develop individual units separately and then bring them together in a unified composition.

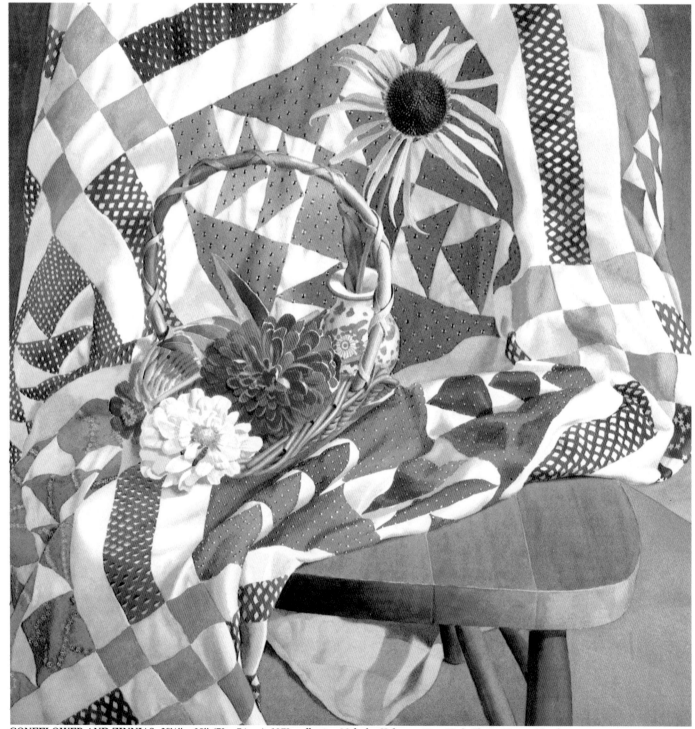

CONEFLOWER AND ZINNIAS, 28½″ x 29′ (72 x 74 cm), 1979, collection Malcolm Holzman, New York. Photo: Nancy Lloyd

One of the challenges of this painting was making the pale pink flowers of the plant look alive and brilliant even when portrayed directly in front of the bright red appliquéd flowers of the quilt. One of the ways Freckelton accomplished this was by allowing the brilliance of the paper to shine through the translucent begonia flowers and treating the bright red cloth flower in a nearly opaque manner. Freckelton has cautioned her workshop students about "losing" the paper when applying a great deal of pigment suspended in a little water because this tends to deaden the object being painted. In this case Freckelton used the technique purposely to her advantage.

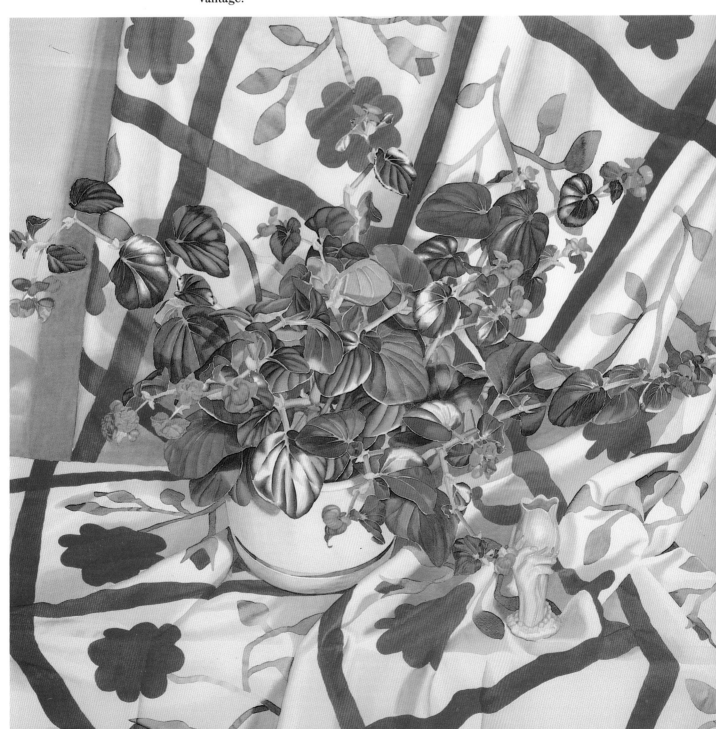

FLOWERING BEGONIA, 40″ x 41″ (102 x 104 cm), 1980, collection Lehman Brothers/Kuhn Loeb, Inc. Photo: Steven Sloman

116

The pattern of light and shadows hitting the wall is as important to the picture as the objects on the table. Freckelton's skill in handling broad, uniform washes makes this kind of presentation possible.

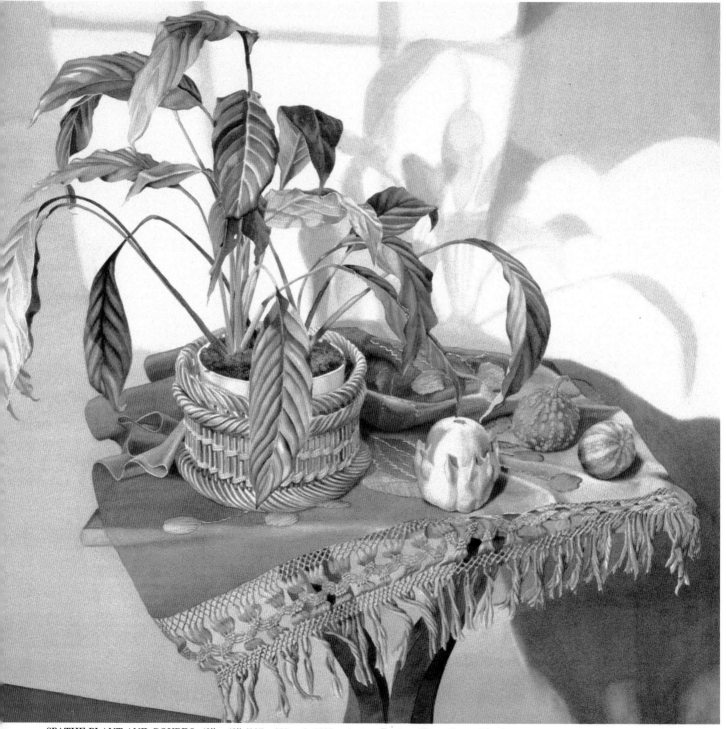

SPATHE PLANT AND GOURDS, *42″ x 43″ (107 x 109 cm), 1980, private collection. Photo: Nancy Lloyd*

Rather than paint the vase of cut flowers straight on, in what probably would have been a static composition, Freckelton chose to shift to a side view of the chair and flowers. The shadows of the chair become more interesting from this vantage point and establish a relationship between the table and flowers.

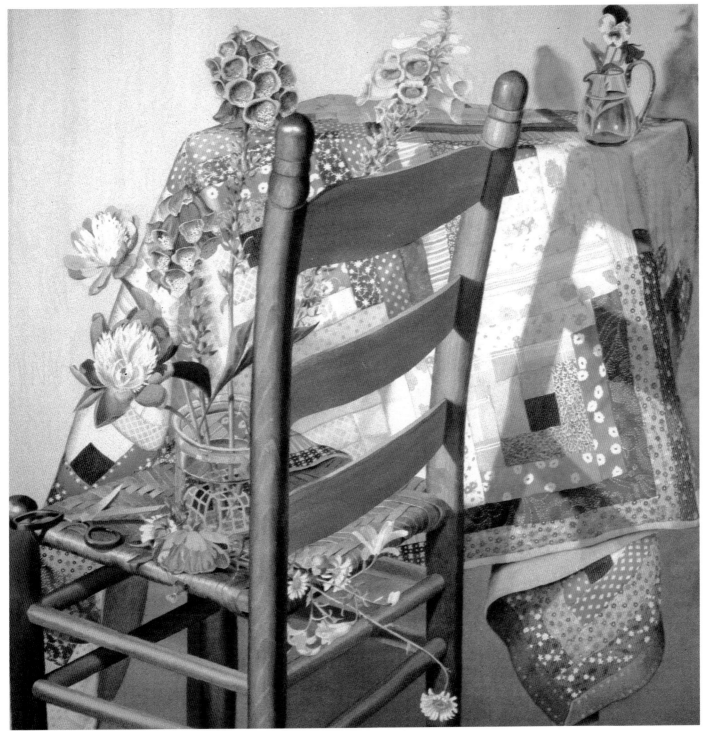

CUT FLOWERS, 44¼" x 45" (112 x 114 cm). 1979, private collection. Photo: Nancy Lloyd

(Below)
Included in the major exhibition "Contemporary American Realism Since 1960," which traveled around the United States and Europe, this painting is one of Freckelton's largest and most ambitious. Separate areas of activity are tied together into a watercolor that could hold its own in any exhibition of painting. In spite of the relatively deep space in the picture, Freckelton chose not to present the background objects as small as they actually appeared in reality. They are painted with the same clarity—and almost the same scale—as the foreground objects.

(Opposite page)
This painting offers an excellent display of the techniques for painting solid, even washes demonstrated in the workshop with Anne Wilfer. It also gives further evidence of how Freckelton handles the use of red colors.

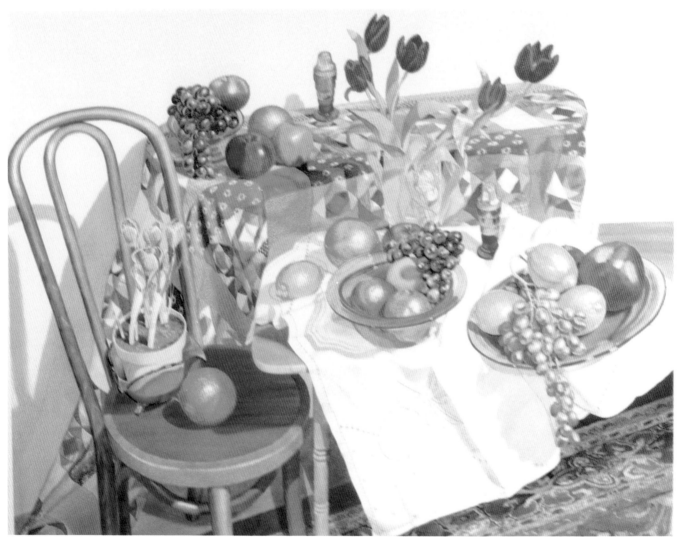

SPRING STILL LIFE, 44½″ x 54¾″ (113 x 139 cm), 1980, collection the artist, courtesy Brooke Alexander, Inc., New York. Photo: Nancy Lloyd

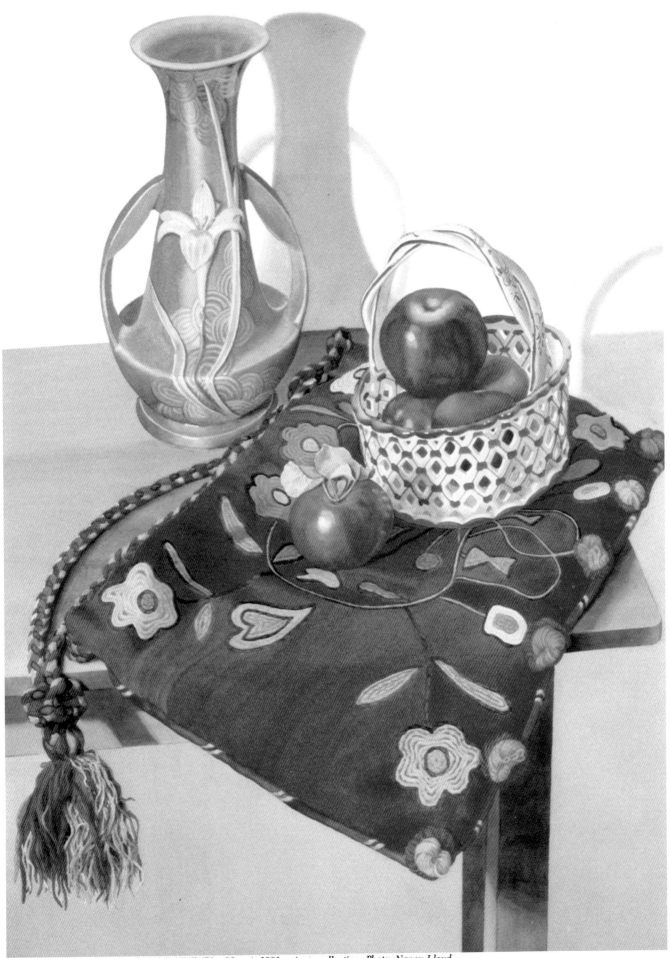

STILL LIFE WITH RED BAG, 29¾″ 38½″ (76 x 98 cm), 1981, private collection. Photo: Nancy Lloyd

The most anecdotal of Freckelton's paintings, this watercolor describes how the artist plans her garden each year in the early spring. Her garden is thought out carefully, and Freckelton establishes a calendar for it long before she moves from her New York loft to the farm.

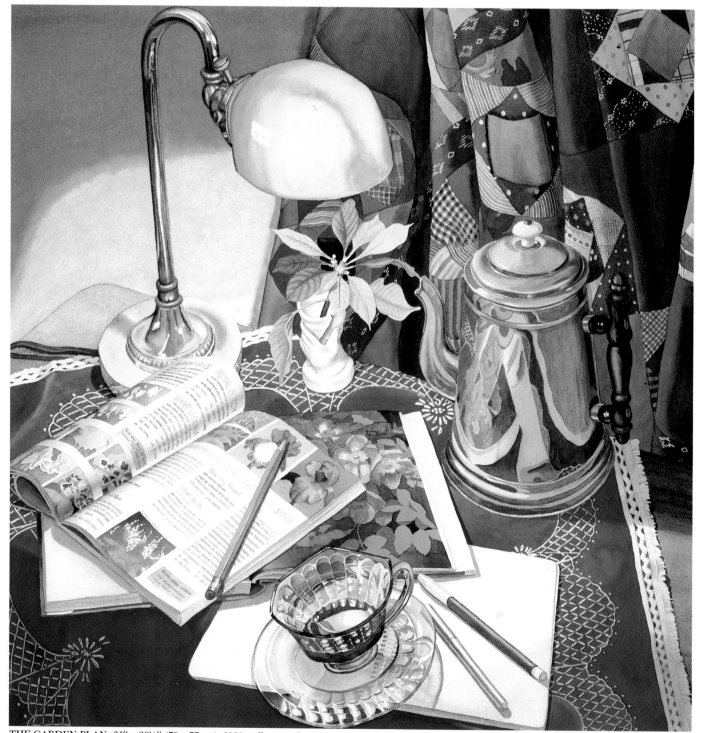

THE GARDEN PLAN, *31″ x 30½″ (79 x 77 cm), 1981, collection The Kemper Group, Chicago. Photo courtesy Frumkin & Struve Gallery, Chicago*

Allowing the white paper to come through the pigment helped Freckelton create the luminous glow of the lamp; she darkened the areas around it to suppress the paper's brilliance. This subject is well suited to the luminous qualities of transparent water-color.

The coffee pot, with the seed catalogs reflected in its surface, is a real tour-de-force, yet it does not reduce the painting to a display of tricks. Its representation is consistent with that of the other objects in the still life.

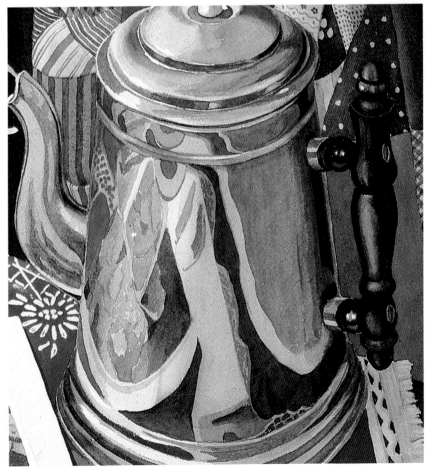

122

(Below)
Done in Freckelton's New York loft in anticipation of her move to the farm, this watercolor incorporates a painting within the painting. Tacked to the wall is a reproduction of a painting by Judith Leyster, a seventeenth-century Dutch painter who is a favorite of Freckelton's. This particular painting is from Leyster's *Tulip Book*, published during the craze in Holland called "Tulipomania" because fortunes were made and lost in speculation on each new bulb.

(Opposite page)
The gridlike composition of the cabinet and begonia is offset by the irregular shape of the cast shadow. Once again Freckelton has used a pattern repeatedly to move the viewer's eye from place to place within the painting. In this case, the pattern is the star shape found in the leaves, quilt, and potholder.

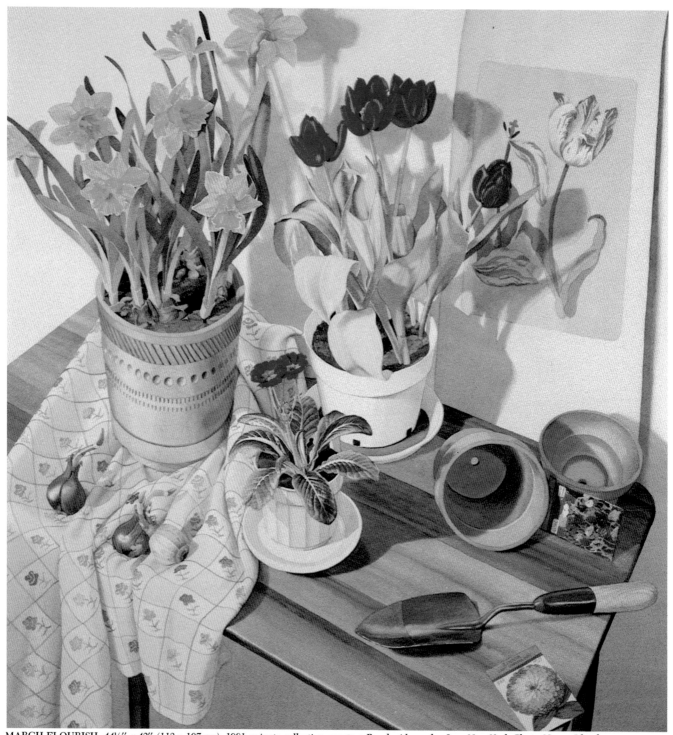

MARCH FLOURISH, 44½″ x 42″ (113 x 107 cm), 1981, private collection, courtesy Brooke Alexander, Inc., New York. Photo: Nancy Lloyd

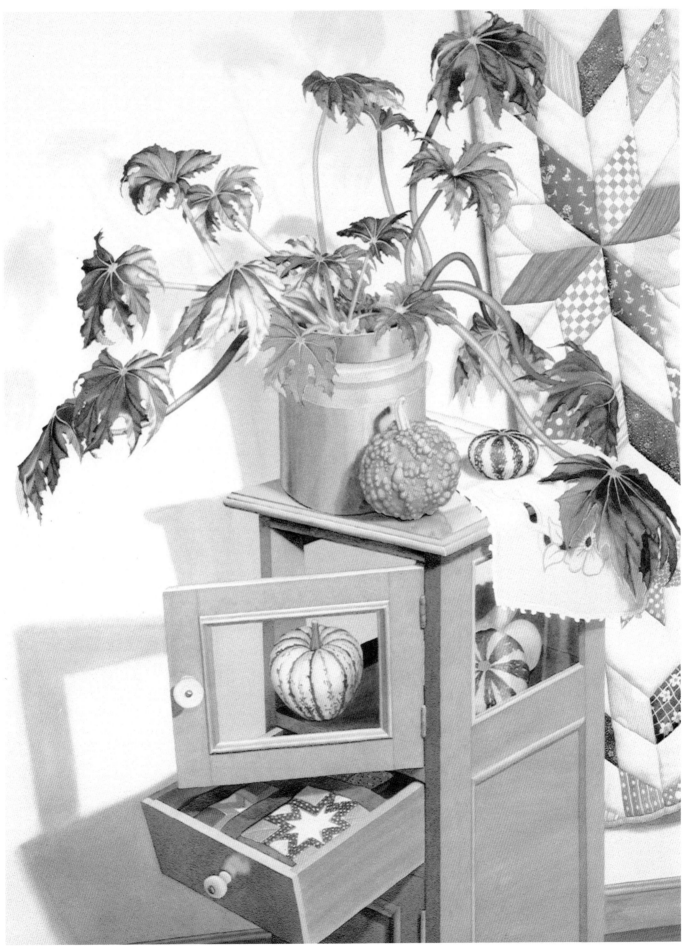

BLUE CABINET, 39¼″ x 49¾″ (100 x 126 cm), 1981, private collection. Photo: Nancy Lloyd

A poster reproduction of this painting was on the wall of the studio when Freckelton met with her workshop student Anne Wilfer, and she talked to the young artist about how the holes in the cabbage became little windows that slowed the pace of movement from the quick thrust of the leaves themselves. She also described how she had painted the tomatoes almost too brightly in order to lead the eye swiftly away from the cabbage to the onions, which softly echoed shape of the tomatoes. They were also used to pull attention in the direction of the chair, over to the furthermost upright, and then swoop quickly down to the cabbage again.

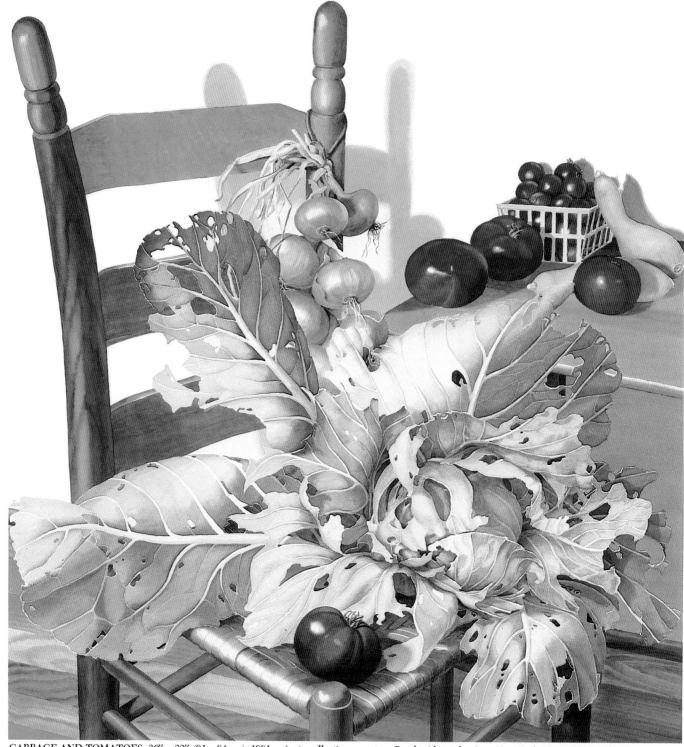

CABBAGE AND TOMATOES, 36″ x 33″ (91 x 84 cm), 1981, private collection, courtesy Brooke Alexander, Inc., New York. Photo: Nancy Lloyd

If we look at these onions with Freckelton's analogy in mind—that a painting is like a musical composition—then it is easy to see that they serve as low background "sounds" that enrich the dominant tones. They are used to echo the similarly shaped but brightly painted tomatoes.

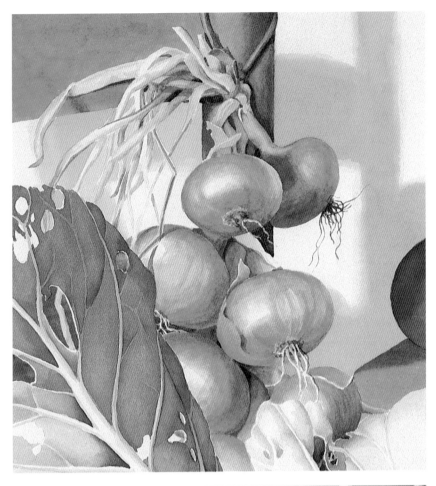

By carefully observing the subtle changes in color and brilliance in the cabbage, Freckelton was able to establish the separate layers of the leaves quite clearly.

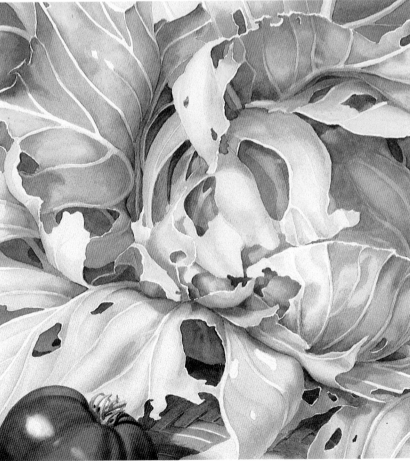

Many of the techniques described by Freckelton
during the workshop with Irene Ingalls are demon-
strated in this painting. Each of the begonia leaves
has been rendered with a different combination of
colors and a different manner of application.

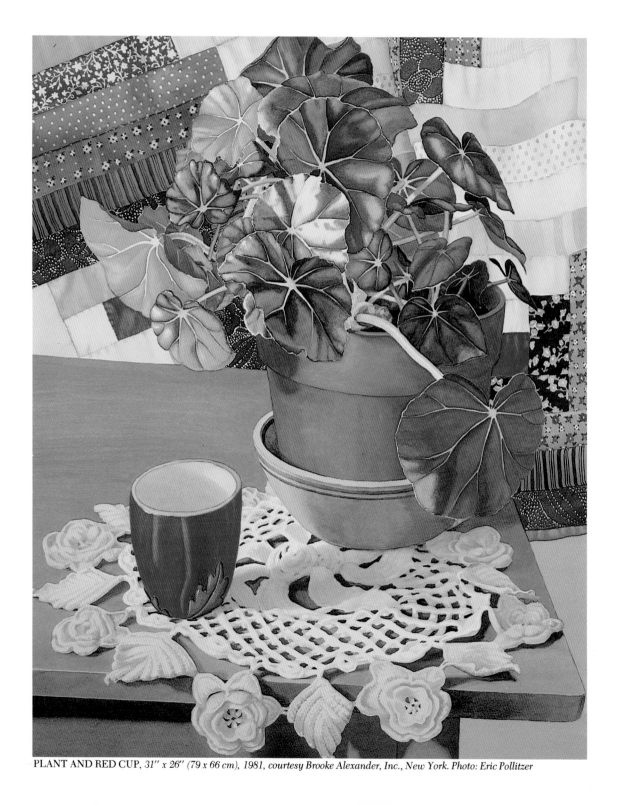

PLANT AND RED CUP, *31" x 26" (79 x 66 cm), 1981, courtesy Brooke Alexander, Inc., New York. Photo: Eric Pollitzer*

Careful observation and meticulous drawing underlie Freckelton's mastery of complex subjects, for she works out the placement of each shape on her paper before beginning to paint an area. Masking out the tiny, detailed patterns of the fabrics with frisket enables her to apply smooth, perfectly controlled washes of color.

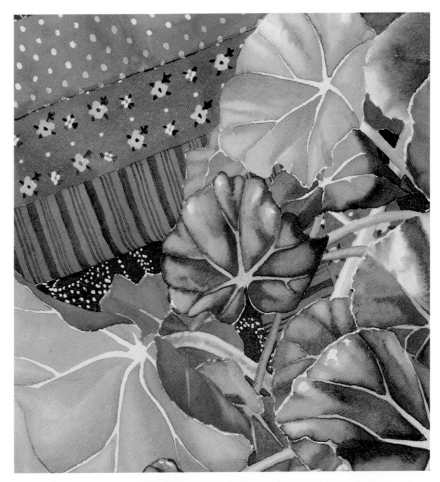

During the Ingalls workshop, Freckelton talked about painting this kind of begonia leaf, which has a red underside that shows through when the leaf is backlit.

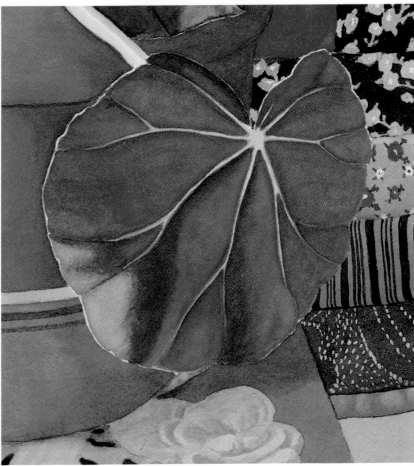

Begonias are favorite subjects for Freckelton, and she often does a painting of one during the pre-garden days of early spring as a kind of "sourdough starter" for her season of painting in the country.

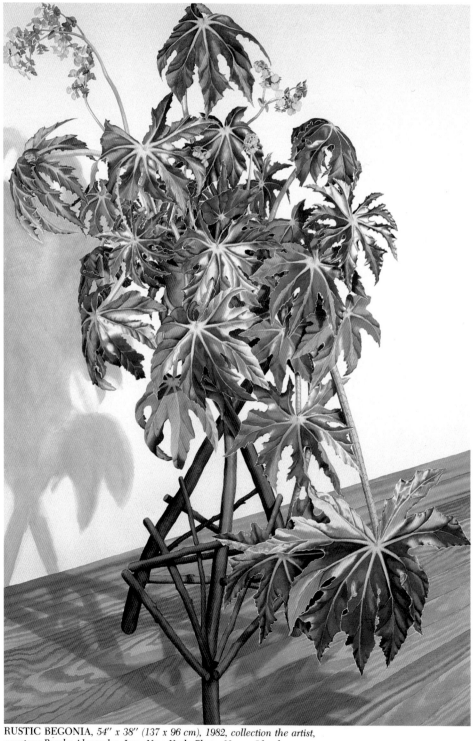

RUSTIC BEGONIA, *54″ x 38″ (137 x 96 cm), 1982, collection the artist, courtesy Brooke Alexander, Inc., New York. Photo: Nancy Lloyd*

Relying on a wide-ranging palette and a repertoire of techniques that differs from leaf to leaf, Freckelton is able to establish distinctions between the closely knit begonia leaves.

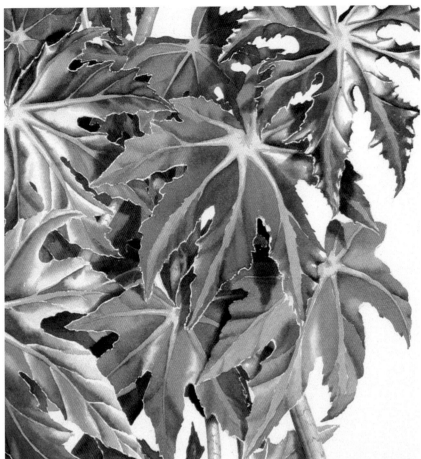

For the delicate petals of the begonia flowers, Freckelton applies a minimum of pigment so as to achieve the lightest, most transparent coloring.

As Freckelton pointed out in the teaching workshops, it is sometimes advisable to paint a shadow first so it can lay uniformly and with continuity under an area that is complex and over which separate colors must be worked quickly. In this case the shadows on the floor boards were painted first; then the boards were painted; and the graining of individual boards was worked into the wet, solid-color stripes of wash.

The beautiful natural forms of the vegetables that
grow in Freckelton's garden provide an endless
source of inspiration for the artist. Here the in-
triguing growth pattern of the plant—the sprouts en-
circling the stem in two different directions at once—
is echoed by the opposing diagonals of the overall
composition.

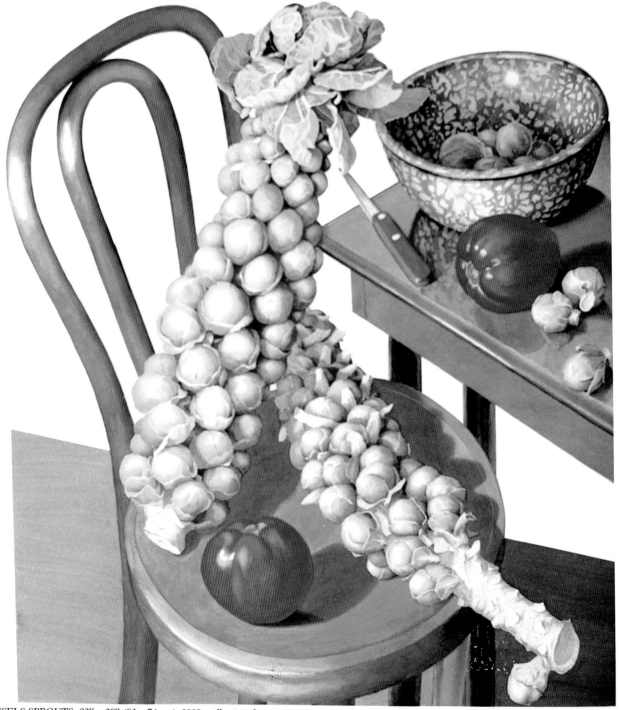

BRUSSELS SPROUTS, *32" x 29" (81 x 74 cm), 1982, collection the artist, courtesy Brooke Alexander, Inc., New York. Photo: Nancy Lloyd*

Freckelton brings together a collection of rounded, concave shapes in this watercolor. Each arc and curvilinear shape is carefully placed to keep the movement flowing throughout the painting. The puckering of the cloth patches is repeated in the bulging leaves and even in the puckered volume of the teapot and cups.

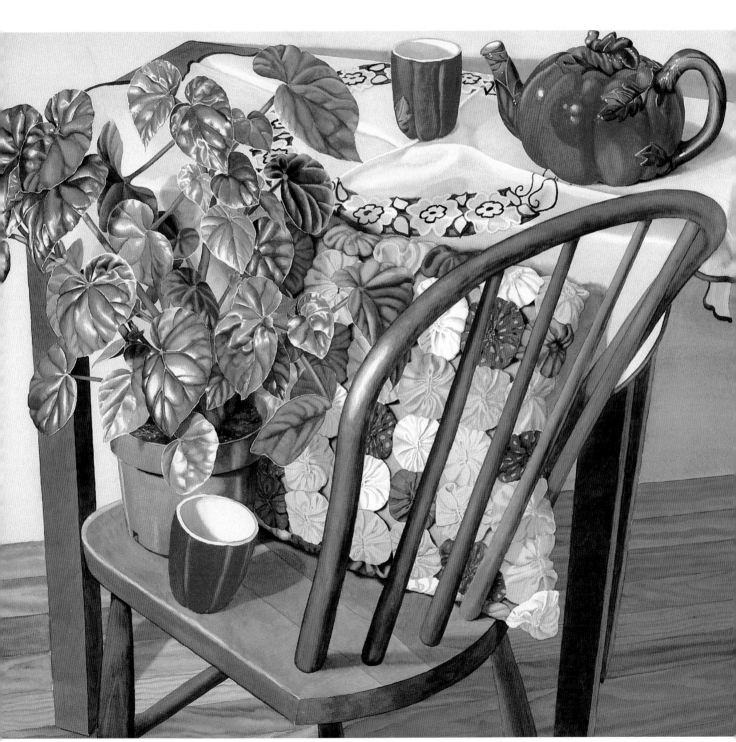

PUFF PILLOW, 32″ x 36″ (81 x 91 cm), 1982, collection the artist, courtesy Brooke Alexander, Inc., New York. Photo: Nancy Lloyd

One of the problems Freckelton faced with this still life setup was the gradation of tone from top to bottom of the painting. The top was dominated by whites and pale colors, the middle contained objects of medium values and intensity, and the bottom was controlled by the dark table, shadow, and floor. One of the ways in which Freckelton overcame this imbalance was to make the most of the active compositional interest on the top to counteract the heavier colors and values on the bottom. The repeated shapes of bagel and hole, appliquéd flower and middle, single peony and center, as well as the quilt pattern, all relate in a coincidental manner which binds the composition in a visual relationship.

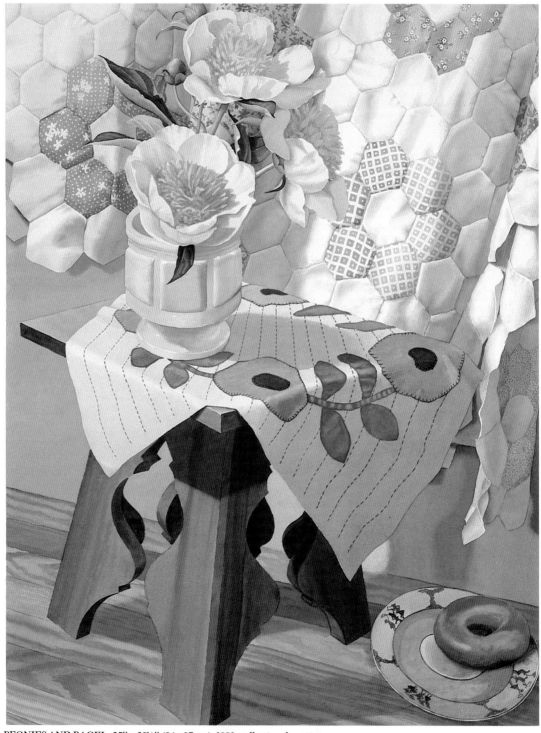

PEONIES AND BAGEL, 25″ x 26½″ (64 x 67 cm), 1982, collection the artist, courtesy Brooke Alexander, Inc., New York. Photo: Nancy Lloyd

The stripe of gray shadow placed deliberately behind the blossoms sets them apart from the background and unifies their forms without Freckelton having to introduce strong, dark shadows inside the flowers to define them.

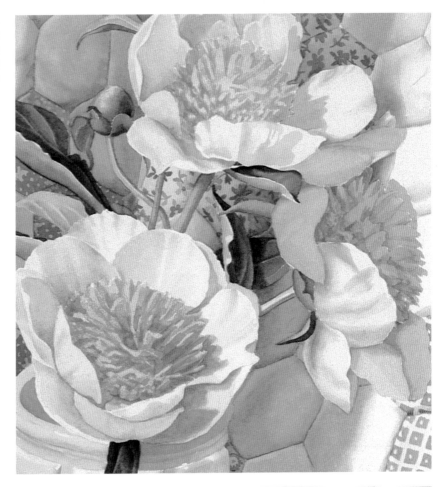

Freckelton considers this to be one of her most successful representations of draped fabric. With seemingly effortless painting, she has accurately recorded the stiff appearance of the starched appliquéd dresser scarf and the soft, flowing forms of the cotton patchwork quilt.

The cabbage head seems to be bursting with energy; as the leaves billow out, their colors shimmer. By limiting both her palette and choice of subjects, Freckelton has made the most of her selections.

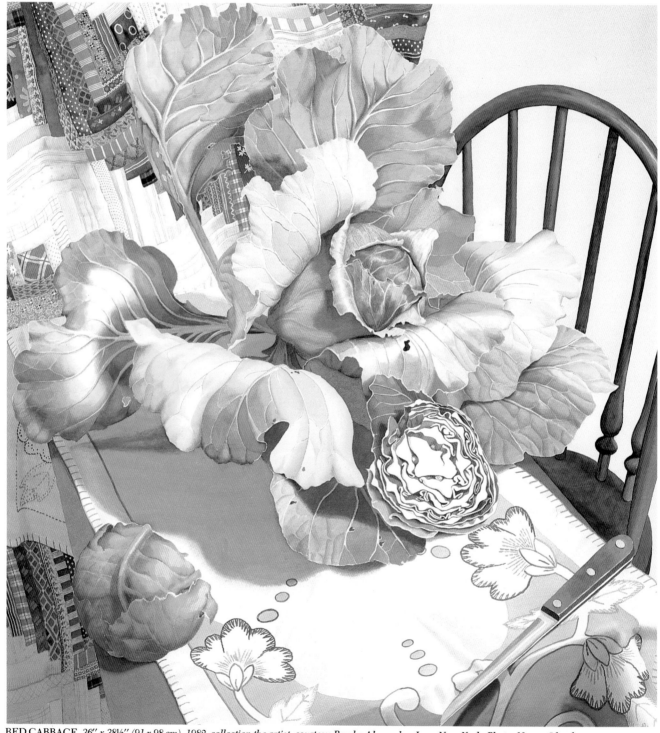

RED CABBAGE, *36″ x 38½″ (91 x 98 cm), 1982, collection the artist, courtesy Brooke Alexander, Inc., New York. Photo: Nancy Lloyd*

Each stroke of the paintbrush was calcu-
lated to accentuate the leaf's flowing lines.
The point here was to give the natural form
energy, not just to present its appearance.

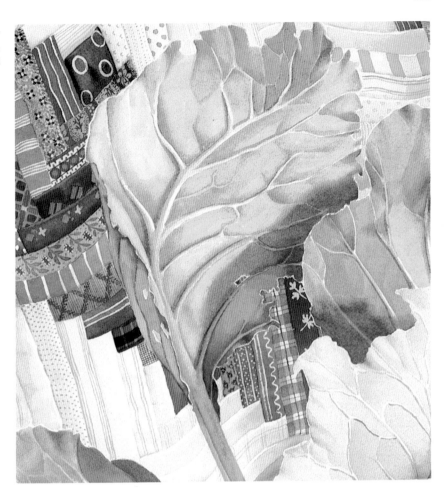

In this detail the whole range of colors used
to portray the cabbage—from its red center
to its green outer leaves—is shown.

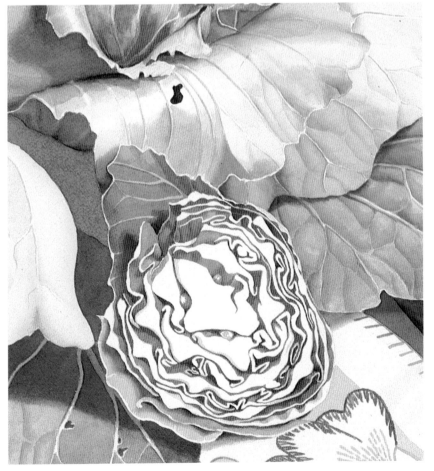

Responding to the natural beauty around her,
Freckelton painted several of the large sunflowers
that were blooming in her garden in late summer.
The large, sometimes awkward-looking flowers are
carefully placed in a sparkling vase and set on a chair
that has the simplest of lines.

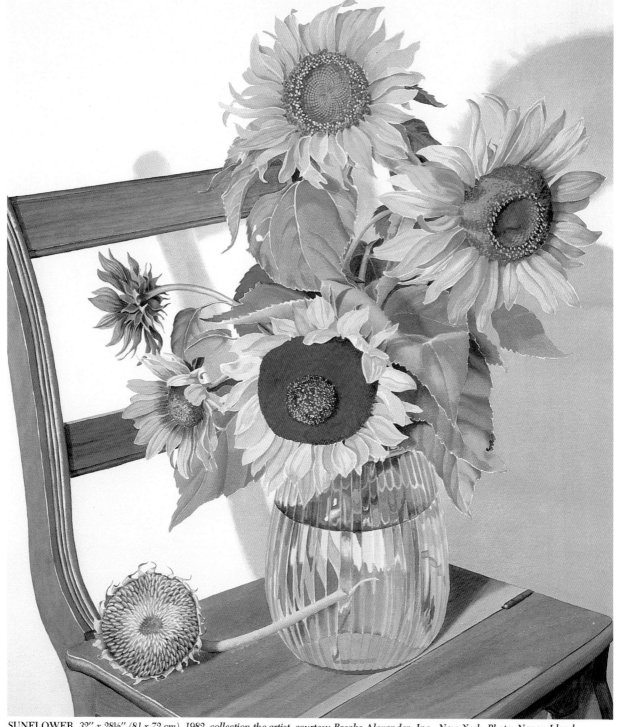

SUNFLOWER, 32″ x 28½″ (81 x 72 cm), 1982, collection the artist, courtesy Brooke Alexander, Inc., New York. Photo: Nancy Lloyd

The lighting on the subject emphasizes the soft qualities of the flower and makes interesting cast shadows on the blank wall behind the chair.

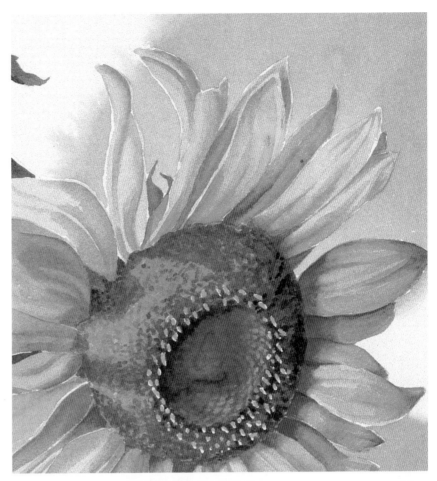

The instructions Freckelton offered Irene Ingalls in the second workshop about painting the appearance of a glass vase are exemplified in this presentation of a many-faceted vase.

STILL LIFE AND OLD LACE. *36″ x 39¾″ (91 x 101 cm), 1982, private collection, courtesy Brooke Alexander, Inc., New York. Photo: Eric Pollitzer*

Many of Freckelton's watercolors are exciting because of the dramatic vantage point from which they are painted, her exaggeration of precariously placed objects, and the diagonals that give her compositions a sense of movement. This painting is unusual in that she pays homage to the traditional frontal point of view, giving a great deal of attention to shape and silhouette and using a picture space so shallow that it almost has the appearance of a bas-relief. Subtle diagonals have been introduced, however, in the direction of the pattern repeat of the lace and in the way the cloth has been folded back to reveal a corner of the table.

In contrast to the classical perspective of *Still Life and Old Lace*, shown on the preceding pages, this composition is distinctly modern in its point of view. Movement is implied by the angle of the chair and the dynamic folds of the quilt.

PEARS AND TOMATOES, 28¾″ x 28¾″ (73 x 73 cm), 1982, private collection, courtesy Brooke Alexander, Inc., New York. Photo: Eric Pollitzer

Freckelton finds interesting relationships between the forms of real fruits and vegetables and manufactured representations of them: the cabbage-leaf-shaped bowl holding the cherry tomatoes and the tomato dish on which the pears are arranged.

INDEX

Editor: Betty Vera
Designer: Robert Fillie
Graphic Production: Ellen Greene